IMAGES
of America

BERWYN

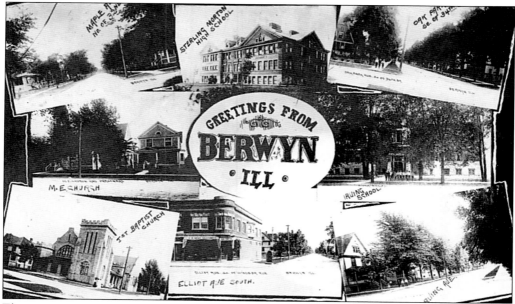

This penny postcard, postmarked June 9, 1910, provided eight Berwyn views for the price of one.

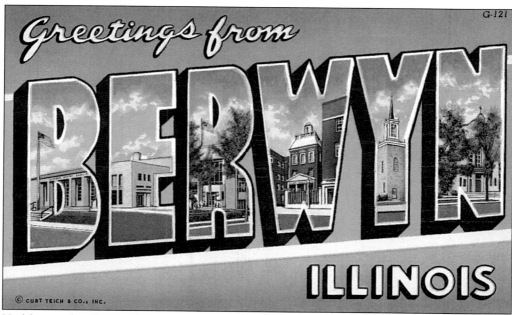

Highly popular during the 1940s, "large-letter postcards" featured small scenic views within oversized capital letters that spelled the names of geographic locations. Here the "B" contains the "new" WPA post office on Cermak Road, and the "N" shows St. Mary of Celle Church at 15th Street and Wesley Avenue.

IMAGES
of America

BERWYN

Douglas Deuchler

ARCADIA
PUBLISHING

Published by Arcadia Publishing
Charleston, South Carolina

Printed in the United States of America

Library of Congress Catalog Card Number: 2005920228

For all general information contact Arcadia Publishing at:
Telephone 843-853-2070
Fax 843-853-0044
E-mail sales@arcadiapublishing.com
For customer service and orders:
Toll-Free 1-888-313-2665

Visit us on the Internet at www.arcadiapublishing.com

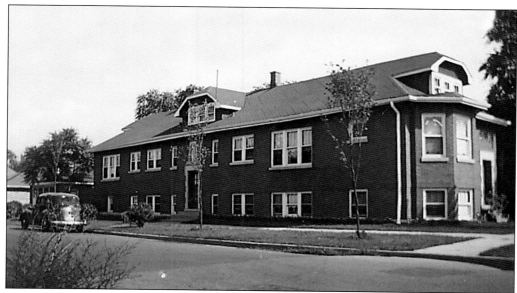

For nearly a century, Berwyn has been called the "City of Homes." The community is blessed with an especially unparalleled collection of bungalows. The purchase of one of these solid brick houses, such as this corner residence at 1401 Home Avenue seen in a 1930s snapshot, was viewed as a definite symbol of upward mobility. Bungalows blurred the traditional distinction between blue-collar and middle-class families.

CONTENTS

ACKNOWLEDGMENTS

I extend my deepest appreciation to the Berwyn Historical Society for making their archives available to me. I would especially like to thank President Lori Thielen, Dr. Ralph Pugh, and Reverend David E. Olson. Their dedication and enthusiasm for preserving and sharing the history of Berwyn with their community is outstanding.

I am most grateful to Chuck Sterba, a generous postcard collector who provided many vintage images.

Thanks to Jason Deuchler for photographing current Berwyn locations.

I'd like to extend a special *gracias* to Antonio Perez for allowing me to include a number of his fine photos.

I am indebted to many people who went out of their way to provide pictures, memories, and encouragement, including: Judy Baar Topinka, Anna Bass, Molly Cavanaugh, Anthony Citro, Richard Clish, Alice Dunn, Danny Dwyer, Gayle Findley, Audrey Fortunato, Mary Hapac Karasek, Vlasta Krsek, Frank Lipo and the Historical Society of Oak Park & River Forest, Nora Laureto, Joe May, Judy McGuire, Therese M. Motycka, Evelyn Popelka, Jim Popp, Ann Proce, Warren Ritzma, Dick Romani, Richard Skelnar, Mario Stamas, Anne Svec, Violet Tantillo, Carlos Tortolero, Virginia Uphues, and John Usmial.

I dedicate this book to my wife Nancy who put up with my increasing clutter and distraction as I kept digging deeper into the story of Berwyn.

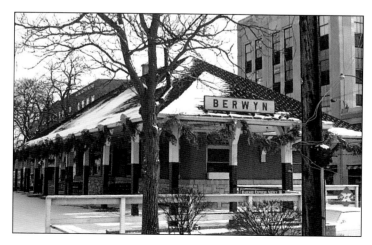

Seen here in the 1980s is the Chicago, Burlington & Quincy Railroad station. This depot was erected by Charles E. Piper and Wilbur Andrews in 1890 when the two realtors began to lay out their new community. Rescued and restored in 1987, it continues to serve hundreds of commuters daily.

INTRODUCTION

At the end of the Ice Age over 13,000 years ago, the area now known as Berwyn was completely reshaped. As the vast glacial ice cap that had covered the region began to melt, it left evidence of its terminal point, such as the rise along Riverside Drive near Harlem Avenue. This slight elevation running northeast throughout the community was once a sandy beach that can still be seen at various points, such as at East Avenue and Scoville Avenue and at Highland Avenue just north of Cermak Road. The melting glacier left behind rolling ridges of solid mud and gravel as it receded northward.

Berwyn thus started out with a dampness problem. Much of the land remained swampy most of the year. Early residents, in fact, kept rowboats handy so they could get around during the rainy season. Flooding was such a constant challenge the wooden sidewalks often literally floated away. As late as 1912, the south end of the community often had so much water standing that it attracted huge flocks of wild ducks and geese. Duck hunting became a very popular pastime in the vicinity.

Deep drainage ditches were dug that crisscrossed the settlement. They were nearly always filled with deep muddy water. The corner of Ogden Road and Ridgeland Avenue was called "Four Bridge Corner" because there were deep ditches on both sides of the road with a narrow bridge across each of them. Mothers tied their children together with clothesline so that if one of them fell in on his way to school, the others could pull him out. But eventually all this marshland was drained, filled in, and utilized.

Berwyn began as part of a 36-square mile territory called Cicero Township. But for over a century it has been a 3.8-square mile, rectangular, independent Chicago suburb bordered on the north by Roosevelt Road (12th Street), on the east by Lombard Avenue, on the south by Pershing Road (39th Street), and on the west by Harlem Avenue.

Berwyn's prime location, with its easy access to public transportation and highways, was a key factor that lured both settlers and commerce into the community. For many generations the city has been home to successive waves of newcomers who often worked long hours to build new lives for themselves and their families.

The City of Homes, as Berwyn has long been known, continues to be recognized for its top-quality housing stock. Although 1920s bungalows are predominant, there is an exciting gamut of residential styles on nearly every street, from ornate "painted lady" Victorians to the "raised ranch" homes of the 1950s and 1960s.

While no individual work can fully document the phenomenal growth and development of such a community, please join me as we "time travel" back via vintage photographs to its early days. My goal is not just to illustrate the life and times of Berwyn, but also to salute and celebrate this most vibrant, fascinating city.

Just before the turn of the twentieth century, Charles E. Piper (1858–1923) became one of the founders of early Berwyn. Along with fellow attorney and real estate speculator Wilbur J. Andrews (1859–1931), Piper purchased 106 acres of land adjacent to the Chicago, Burlington & Quincy Railroad and began to lay out the new community like a board game. Knowing that their subdivision would require a train station to service commuters who worked in the city, Piper and Andrews had a depot constructed at their own expense. On May 17, 1890, they officially christened their town Berwyn, selecting the name of a picturesque suburb of Philadelphia from a railroad timetable. They simply liked the sound of it.

One

THE BIRTH OF BERWYN

After the Black Hawk War, the Native American population of northern Illinois was forcibly evicted from the region in the 1830s. After the Indians left and moved further west, beyond the Mississippi River, the land became available for white settlers. At a time when anti-Irish feeling was strong, many Irish workers were recruited to help dig the Illinois and Michigan Canal that would effectively open waterway travel between the Great Lakes and the Gulf of Mexico. Many of these Irish laborers and their families remained after the digging of the canal was completed, establishing small farms in the area that is now southwest Berwyn. The canal is now buried beneath the Stevenson Expressway.

In 1864, railroad tracks were laid through the south section of the community, creating a link from Chicago to Aurora. But the settlement remained rural and essentially undeveloped for several decades.

Berwyn's early pattern of growth was unique. There was no central area or nucleus from which the community expanded. Berwyn began as two separate communities with vast stretches of marsh and farmland in between. For decades, settlers north of 16th Street were technically living in an Oak Park subdivision called "South Oak Park." Only two dirt roads, Oak Park Avenue and Ridgeland Avenue, crossed the vast prairies, cabbage patches, and onion fields that separated the two settlements.

Berwyn and several adjacent communities continually agitated to break away from Cicero Township, but not all were successful. Austin failed in its efforts to become independent and eventually became part of Chicago. But on November 5, 1901, both Oak Park and Berwyn voted to go it alone as independent municipalities.

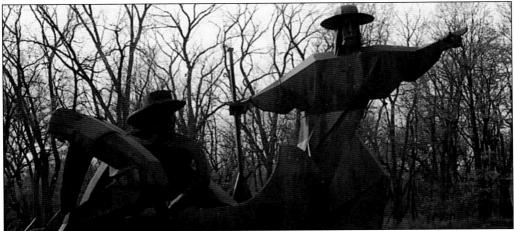

In 1673, Louis Joliet (1645–1700), a Canadian explorer, and Father Jacques Marquette (1637–1675), a French Jesuit priest, were motivated to tour the wilderness to "convert the savage" and became the first non-natives to pass through the region. They were searching for a route to the Mississippi River. A huge metallic sculpture (1989) by Rebechini on Harlem Avenue just north of I-55 commemorates Marquette and Joliet's portage from the Chicago River to the Des Plaines River.

Much of the area just south of Berwyn was a vast swampland called "Mud Lake." South Berwyn, too, was often under water. Native Americans hunted here, but did not establish villages. To portage through the area involved wading and pushing the canoes through the thick muck when the water was not deep enough to float the boats. During the next century and a half, this portage would be used by fur traders, missionaries, and explorers.

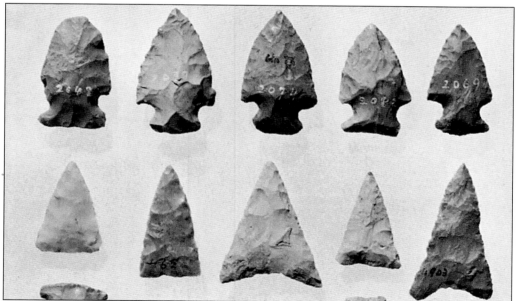

Although there were Native American villages along the heavily traveled Des Plaines River, the marshy nature of the future Berwyn area discouraged Indian settlement. Early residents often found arrowheads and weapon points while their homes were being constructed. Such artifacts document the fact that the area was once a rich hunting ground for the Sac, Fox, and Potawatomi Indians.

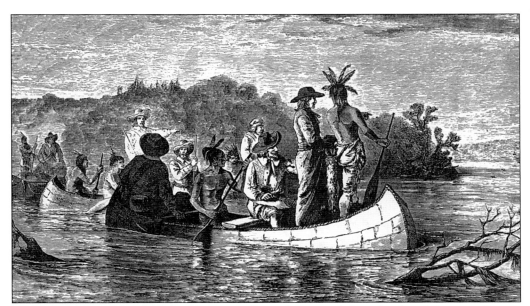

In August 1673, Father Jacques Marquette, Louis Joliet, and their five hired "voyagers" came through the marshy, mosquito-infested region as they began their epic journey through the Chicago Portage, carrying canoes and gear across the swampy overland pass to the Des Plaines River. Joliet dreamed of a canal through this portage, a project eventually supported by the Illinois legislature in the 1800s.

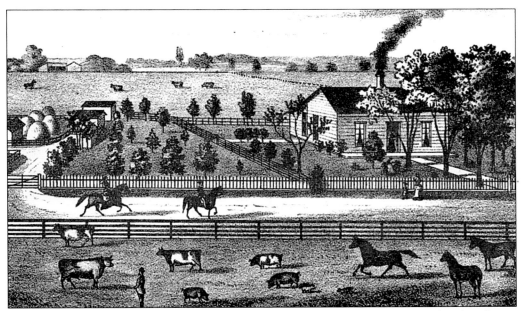

The earliest settlers in the Berwyn area, mostly Irish, came in the 1830s to dig the Illinois & Michigan Canal (now buried under the Stevenson Expressway), which opened waterway travel from the Great Lakes to the Gulf of Mexico. All of Berwyn, Oak Park, and much of the adjacent West Side of Chicago were originally part of Cicero Township, a 36-square mile area established in 1857. This particular small farm is unidentified.

Chicago's first mayor, William Butler Ogden, a man of great wealth, purchased a portion of "Berwyn" land, including the diagonal Indian trail that would eventually be known as Ogden Road. Ogden had the route developed as a plank road that was heavily used by stagecoaches. In addition to regular passengers going back and forth to Chicago, stagecoaches often carried mail, too. This 1965 photo was taken at Old South Berwyn Days, a historic celebration that featured free rides via stagecoach, just like in the nineteenth century.

Though it was not yet called Berwyn, the community was born in 1856 when Thomas F. Baldwin, a riverboat transportation tycoon, bought up 347 acres, planning to develop it as a suburb for the wealthy. Baldwin named his new subdivision LaVergne, but his settlement was only accessible by Ogden Avenue. This view shows the Ogden plank road from Wisconsin Avenue, looking toward Harlem Avenue. The value of Baldwin's land increased dramatically in 1864 when the Chicago, Burlington & Quincy Railroad laid tracks through the middle of it. Baldwin devoted much time and money to developing LaVergne as an aristocratic enclave, building streets and importing thousands of shrubs, maples, ash, poplar, cedar, pine, and elm trees to beautify his dream community.

Chicago's first mayor, William Butler Ogden, had substantial land holdings in LaVergne, but to his dismay it was often under water. To drain the old diagonal Indian trail that became the plank toll road now known as Ogden Road, he had deep ditches dug on either side of the thoroughfare. Drivers were never certain when their wagons or stagecoaches might sink into the mud until planks were laid.

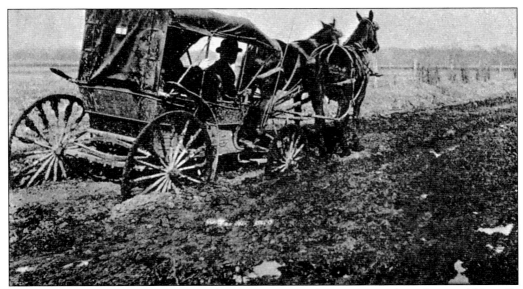

This covered buggy was no surrey with a fringe on top. It was a rugged rig that could handle the hub-high mud of early Berwyn. In those days, kids slopped through the muck barefoot, searching for frogs and "crawdads." Many residents tethered cows on the open prairie. Only two dirt roads, Oak Park Avenue and Ridgeland Avenue, crossed the vast fields and marshes which separated the north and south settlements.

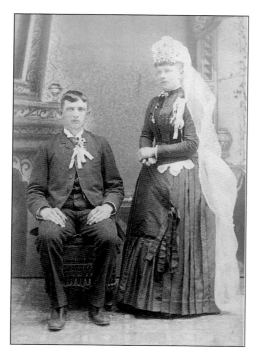

A white wedding gown to be worn only once was considered an impractical garment in early Berwyn. Brides often wore their best dress or a traditional ethnic wedding costume. An expensive, one-time use white dress came into fashion in the early twentieth century as a way of showing off a family's status.

Early Berwyn was actually two separate communities. The upper settlement, bordering along Oak Park, extended from 12th Street to 16th Street, from Ridgeland Avenue to Harlem Avenue. The house in this 1897 photo is still standing at 1212 Kenilworth Avenue.

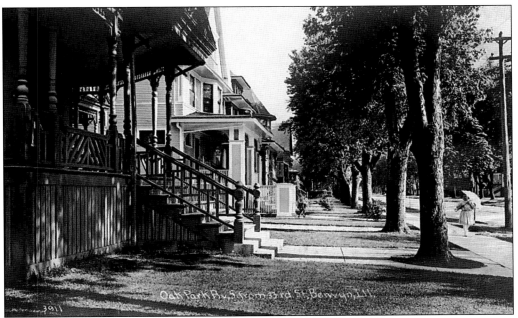

This postcard view of Oak Park Avenue looking south from 33rd Street shows a block of homes with wide, ample porches, typical of the late Victorian period. All these residences were cleared in the late twentieth century to make way for an expansion of the MacNeal Hospital parking lot.

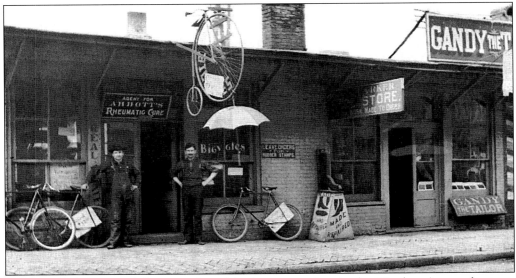

The bicycle fad was in full swing when this photo was taken in the Windsor Avenue business district near Grove Avenue. Bicycles were priced at $22 apiece, which made them a "big ticket" item in 1895.

The tall Colonel Deardorff home, 6534 34th Street, has a foundation that used huge red granite stones obtained from the New Hampshire state building when the World's Columbian Exposition was dismantled at the end of the fair in 1893. Such homes often had "ballrooms" located on the 3rd floor for entertaining during the cooler months. Today the residence, covered in aluminum siding, is surrounded by many others, yet it is still the tallest home on the block.

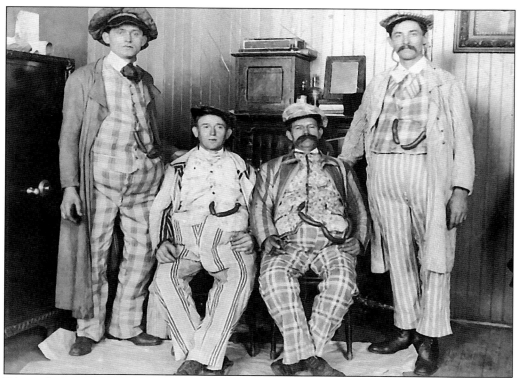

Ethnic humor, now considered insensitive and politically incorrect, was once immensely popular. Here four 1890s businessmen portray newly arrived European immigrants in an amateur theatrical. Realtor John J. Kelly, Sr., is second from the left. The other "greenhorns" are unidentified. Note their mismatched clothing, the oversized mustaches, and the strings of sausages hanging from the performers' pockets.

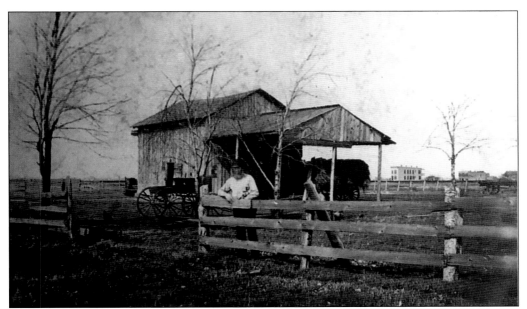

The Ritzma farm, situated in what is now west central Berwyn, seemed so remote that many dubbed it "Oklahoma." The barns and haystacks were located where Morton West High School now stands. The deep black soil of early rural Berwyn proved so fertile that a number of farms survived into the 1920s.

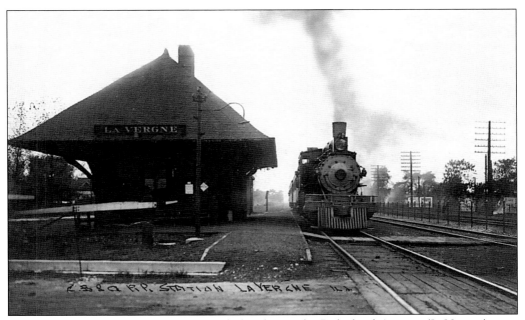

The first residents of early Berwyn mostly lived near the Ridgeland Avenue (LaVergne) train station, established in 1883. This postcard view was mailed in 1912. Berwyn was served by the Chicago, Burlington & Quincy Railroad, which many simply called the "Q." At the time, eight miles out of Chicago's Loop was considered "far off in the hinterland," but more than any other factor, the many trains motivated newcomers to settle in the community.

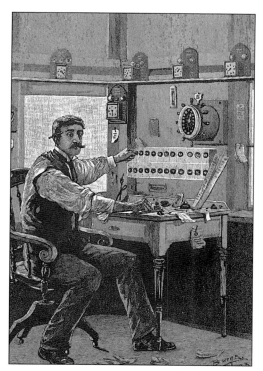

In the early 1890s a railroad came through on Nineteenth Street, but the area was then so sparsely populated that the line was never financially successful. One can still see where Nineteenth Street splits into two parts east of Ridgeland Avenue, where the track once ran. But the Chicago, Burlington & Quincy Railroad played a decisive role in Berwyn's history. The station just west of Oak Park Avenue was a bustling center of early suburban life.

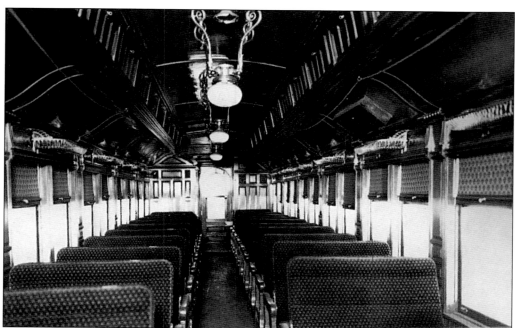

Berwyn was served by scores of daily passenger trains going in each direction. This commuter car of the late 1890s shows seats closely-spaced and gas lamps overhead. When possible, passengers avoided sitting in the front cars so they wouldn't get showered with cinders blowing in the open windows.

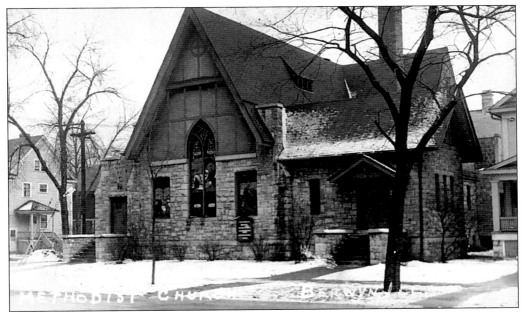

The Gothic Revival style First United Methodist Church, 3409 Grove Avenue, erected in 1891, is listed on the National Register of Historic Places. The walls were built of limestone quarried in the nearby Lemont area. Before the church was finished, services were held in founder Charles E. Piper's home, 3427 Oak Park Avenue. In 2004, this historic house of worship was sold to the New Christian Life Fellowship.

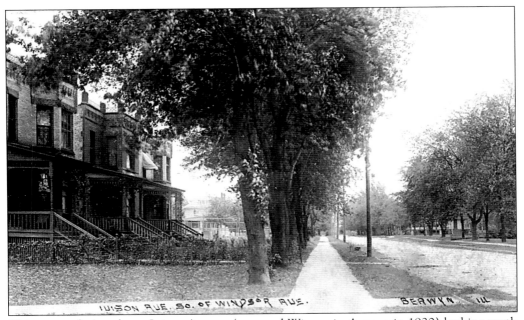

This postcard view shows Ivison Avenue (renamed Wisconsin Avenue in 1920) looking south from Windsor Avenue. In those days, many families routinely collected horse manure from the streets to enrich the soil in their vegetable patches and flower gardens.

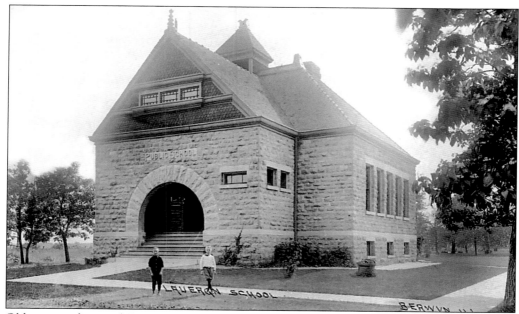

Old-timers often said Berwyn was "born" in 1888 with the transfer of a plot of land at the intersection of Ogden Avenue, Ridgeland Avenue, and 34th Street for the erection of a school building. There were fireplaces in each of the two classrooms in this stone schoolhouse, called the LaVergne School. Despite community protest, the 50-year-old structure that was often dubbed "the cradle of Berwyn" was razed in 1938. It was replaced by a larger building to the west on the same lot that is still standing.

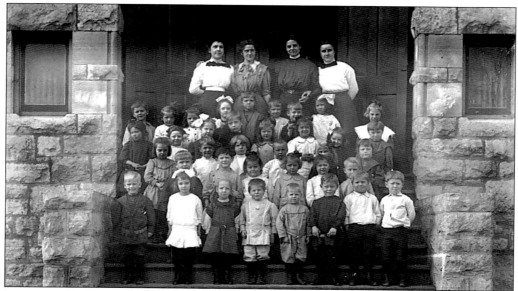

These pupils were enrolled at the LaVergne School in 1910. A child's education at that time depended upon the financial situation of his or her family. Many children joined the labor force right after graduation from eighth grade, supplementing their family's income until the day they left home to get married. "Everybody works" was the mantra of many families.

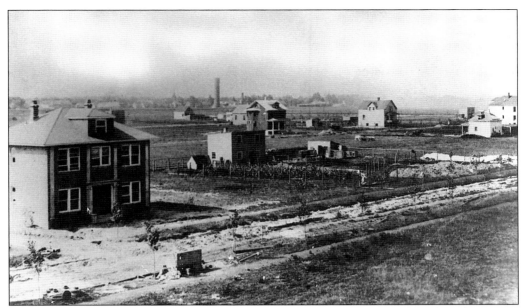

During the 1890s, Berwyn's population continued to rise, despite the fact that there were no sewers, no gas, no electricity, and no water system in the village. But there were wooden sidewalks, outside privies, and each home had a well and a large wooden cistern.

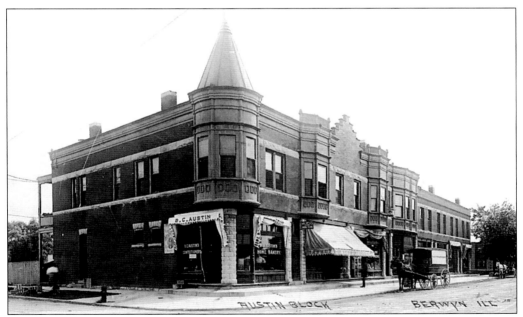

Windsor Avenue and Stanley Avenue, on both sides of the railroad tracks, became Berwyn's first shopping district. Note the delivery wagon in front of the bakery. The Victorian details of the "Austin Block," southwest corner of Grove Avenue and Windsor Avenue, such as the turret and ornate trim, were removed years ago. Today the structure is headquarters for an Italian *ristorante*.

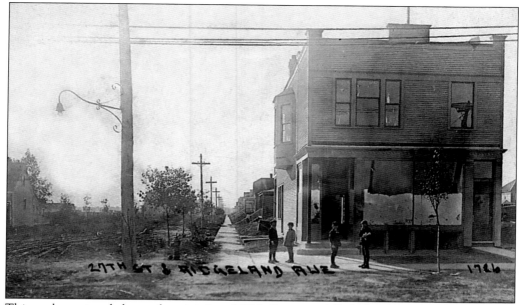

This early postcard shows the vicinity of 27th Street and Ridgeland Avenue in LaVergne. Most commercial buildings included 2nd floor residential apartments for the store owners and their families.

There were only two north-south dirt roads which ran the length of early Berwyn: Oak Park Avenue and Ridgeland Avenue. They each crossed the wide prairies and vegetable farms that separated the two communities. Many of the stately elm trees that line Berwyn streets in early photos were lost to Dutch Elm disease in the 1960s and 1970s.

Though it was still quite rural and much of the community was yet to be developed, Berwyn in the late nineteenth century attracted an increasing number of prosperous Chicagoans who were drawn to Berwyn because of its many churches and its anti-saloon stand. They worked feverishly for independence from Cicero Township, fearing that if Berwyn didn't "go it alone" they would lose their ban against alcohol. This stylish but unidentified Berwynite is wearing the height of fashion, c.1900.

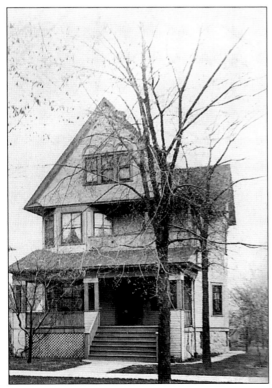

Berwyn front porches were heavily used by young couples as "courting places." This tall home, 3217 Wisconsin Avenue, no longer has a balcony and the porch is enclosed.

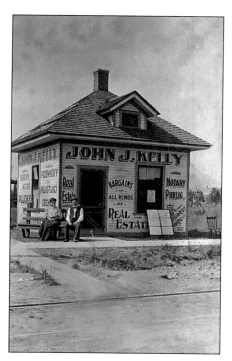

John and Honora Kelly are seated on a bench in front of the Kelly Real Estate Office, 12th Street just west of Oak Park Avenue, in 1895. "Honest John" Kelly (1866–1933) was a builder, realtor, insurance man, and tireless community promoter. He sold lots in north Berwyn; Piper and Andrews cornered the market in the "south end." This tiny structure was an early exercise in one-stop shopping. In addition to real estate, the Kellys sold ice cream, cigars, candy, and newspapers.

This turn-of-the-twentieth century photo shows 6823 and 6831 34th Street. Building lots were more than ample to accommodate a carriage house or stable, an outdoor privy, a chicken coop, and a backyard vegetable patch. The mud streets were often so impassable, however, that realtors avoided showing lots to would-be buyers following a heavy rain.

Two

EARLY
TWENTIETH CENTURY

During the early 1900s, after Berwyn broke away from Cicero Township, the town achieved a level of stability and prosperity.

The "City of Homes," as it was often dubbed, managed to keep industry at bay while remaining strictly a residential community. Because of the convenient, affordable public transportation, Berwyn became one of the most popular of the commuter suburbs. Many residents worked in the Loop, but thousands of others took advantage of the unlimited employment opportunities available in the nearby Western Electric Hawthorne Works. This massive industrial plant in adjacent Cicero manufactured all the telephones being made for the Bell System.

Berwyn's first big growth spurt occurred in the south portion of the community nearest the "Q" tracks. Simultaneously, there was a growing neighborhood north of 16th Street, bordering Oak Park. Each of these two separate settlements had their own churches, stores, clubs, and transportation. A vast expanse of prairie continued to stretch between them.

On June 6, 1908, the villagers voted unanimously to accept a city charter to become known as the City of Berwyn.

As the first decade of the new century drew to a close, the automobile was becoming more affordable. Most new homes were now equipped with indoor plumbing, electricity, and telephones.

During the 'Teens, an increasing number of Berwyn's newcomers were first- and second-generation Czechs and Bohemians seeking social and cultural homogeneity outside their crowded Chicago neighborhoods.

After the Armistice that ended World War I, Berwyn began an unprecedented building boom.

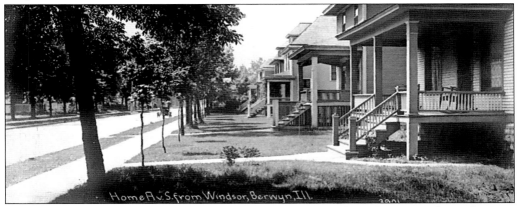

There were postcard views of nearly every block in Berwyn in the early 1900s. This is the 3300 block of Home Avenue looking south from Windsor Avenue. Before television and air conditioning, families spent summer evenings on their wide front porches and knew their neighbors well.

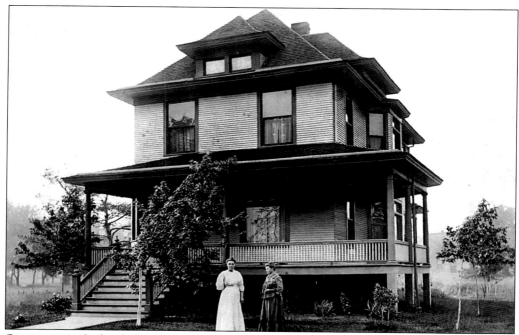

Owning a single-family home became the American Dream in the 1900s. The widely popular Four-Square style house had a pyramidal roof, was set on a raised basement with the first floor approached by steps, and had a wide porch running the full width of its first story. This home at 3309 Wesley Avenue has been much adapted since this 1907 photo was taken. The porch is now enclosed and the north window (upstairs left) was rebuilt as a bay.

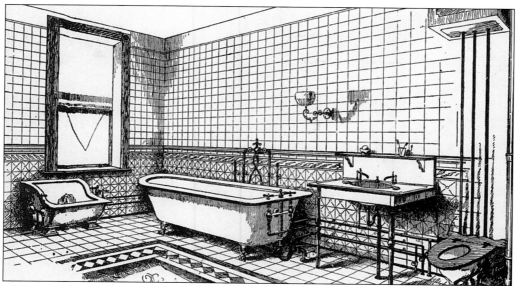

Although indoor plumbing is taken for granted today, in the early twentieth century it was a revolutionary innovation for many Berwyn home owners. Newcomers who had previously lived in city tenements were used to sharing outdoor toilet facilities with other families. This 1901 "sanitary bathroom" was state-of-the-art with its claw-foot tub, pedestal sink, and exposed pipes.

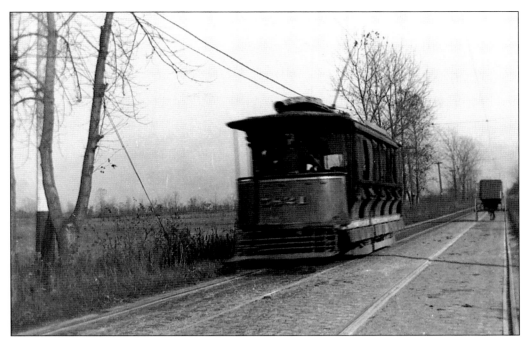

This eastbound streetcar is one of the summer trolleys that traveled back and forth along 12th Street (now Roosevelt Road). Such open cars had canvas curtains that passengers could roll up for better ventilation on hot days or roll down when it rained. The fare for decades was a nickel. Commuters could also purchase monthly passes much as people riding the trains do today.

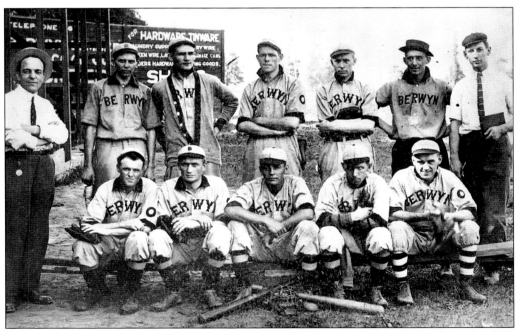

Sporting events were a venue where everyone in the community could meet and mingle while supporting local teams. Baseball drew especially huge crowds of fans.

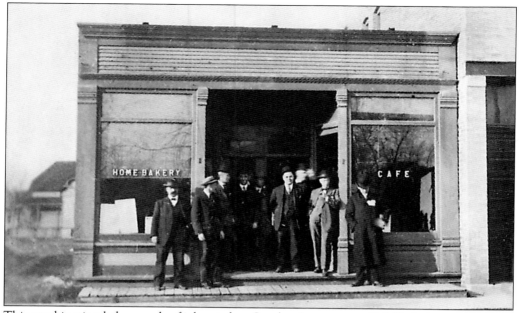

This combination bakery and café, located on Stanley Avenue near Oak Park Avenue, was one of south Berwyn's early thriving businesses. Opossums, rabbits, skunks, and raccoons often made their homes beneath the wooden sidewalks.

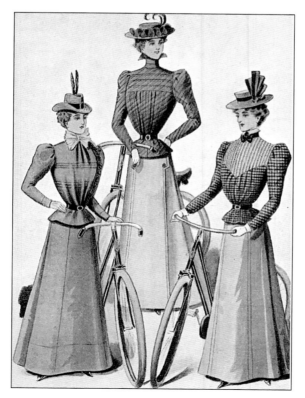

Women increasingly participated in "feminine" sports, such as golf, tennis, cycling, and ice skating. Besides providing exercise, the bicycling fad allowed young Berwyn women to display their sportiest fashions, as can be seen in this 1902 newspaper ad.

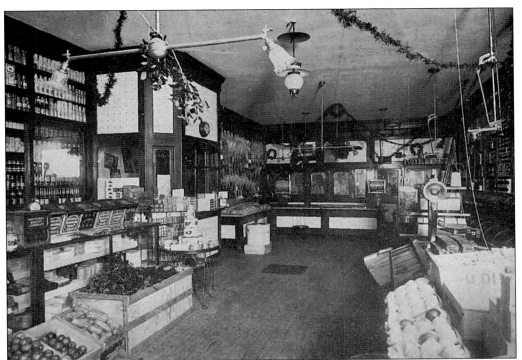

There was no electrical refrigeration in use at the Frank Hamm Grocery, 6741 Windsor Avenue, in 1915. Self-service was still a thing of the future. Although many items were displayed in crates, bins, and bushel baskets, the assistance of a clerk was needed for most customers' requests.

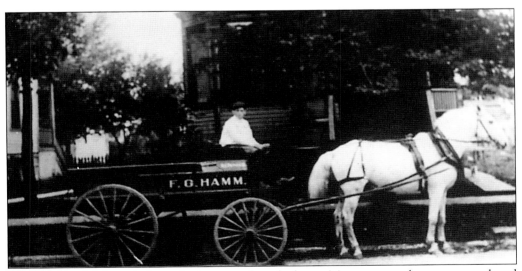

People often did their daily marketing over the telephone. Many teenage boys were employed as wagon drivers for various markets. Home delivery was the rule, not the exception, in the early twentieth century. The Hamm market, which opened in 1905, was razed during one of MacNeal Hospital's massive expansions.

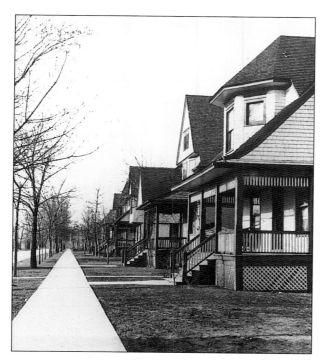

This view, looking south at 3420 Grove Avenue, shows the young elm trees of the early 1900s. Sixty years later when these trees were full grown and formed a lush canopy over Berwyn streets, many of them became blighted by Dutch Elm disease.

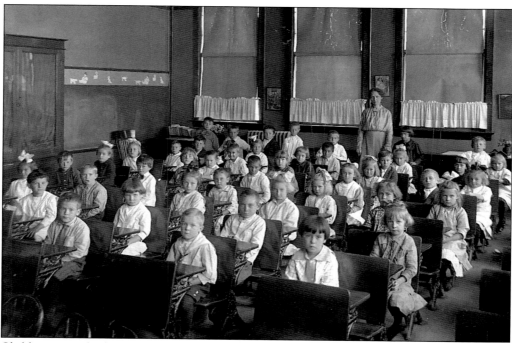

Children started school in first grade, not kindergarten, in the early twentieth century. Pupils had to sit still at desks bolted to the floor. Thinking was discouraged in favor of memorizing facts and noble thoughts. This postcard photo was taken at Emerson School, 31st Street and Kenilworth Avenue, c. 1914.

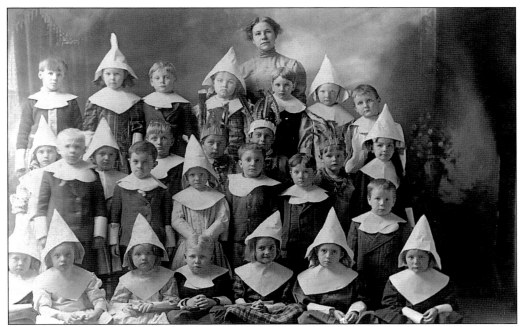

This 1909 group of pupils from Irving School, 35th Street and Kenilworth Avenue, is dressed to celebrate the Pilgrims' first Thanksgiving. The children of immigrants learned English quickly in a total immersion.

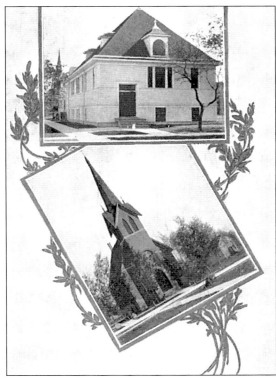

The Swedish Baptist Church (top) and the Swedish Lutheran Church (bottom) in the Upsala or "Swede Town" neighborhood are seen on this 1908 postcard. In 1950, the Baptist Church was rebuilt as the Oak Park Avenue Baptist Church at 31st Street. The bottom 1899 red brick structure survives on the southeast corner of 31st Street and Euclid Avenue as the First Lutheran Church of Berwyn.

Although education often consisted of copying, memorization, and recitation, there were occasional special events and "field days." These second graders at the LaVergne School in 1918 are about to celebrate the first of May with a May Pole dance.

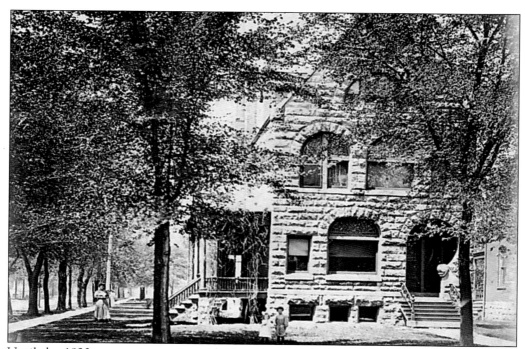

Until the 1920s, many streets in north Berwyn were called by the names used in Oak Park, which didn't match those in the "south end" of Berwyn. But with a mile and a half of open prairie in between, it didn't seem to matter much. This home, 3144 Berkeley Avenue, is now 3144 Wenonah Avenue. The home currently has a wide, wrap-around stucco porch. The cement griffin at the top of the structure cannot be seen in this 1908 postcard view.

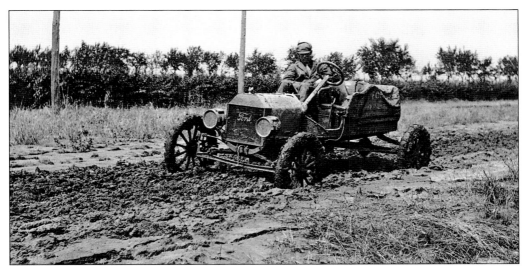

There was nothing fancy about the hand-cranked Model T Ford. The "flivver" had no speedometer, no bumpers, no spare tire, and no temperature gauge. But in the days when automobiling was a constant adventure, this affordable, dependable motor car was popular with Berwynites.

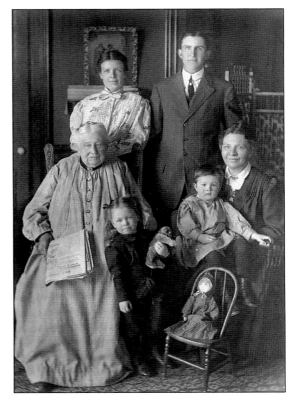

In the 1890s, Berwyn founders Piper and Andrews, a pair of savvy real estate speculators, advertised their new suburb in Swedish newspapers. Soon immigrant families settled in south central Berwyn in a section called Upsala or "Swede Town." The photo shows four generations of the Anderson family on Clinton Avenue in April 1910. Close-knit family units living together under one roof were often multi-generational in those days.

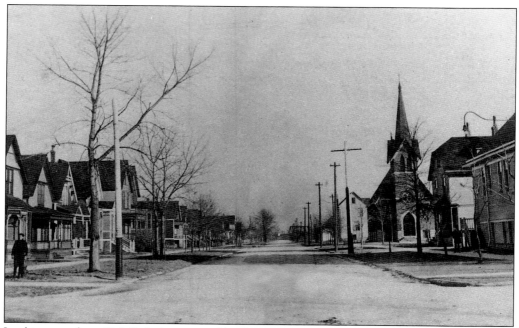

Looking east from Oak Park Avenue at 31st Street in 1906, we see part of the Upsala or "Swede Town" neighborhood, with the Swedish Lutheran Church at the right.

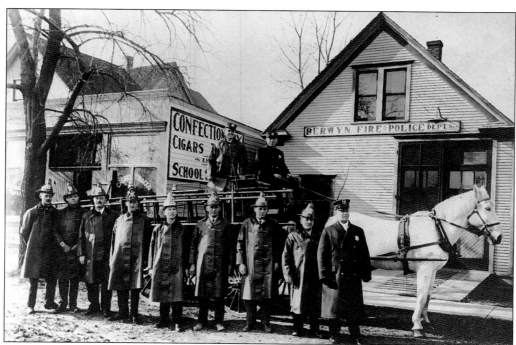

In 1914, the north Berwyn police and fire departments shared the same frame building on Euclid Avenue near 14th Street. The fire department was manned by one paid supervisor per shift, with the remainder of the personnel made up of volunteers.

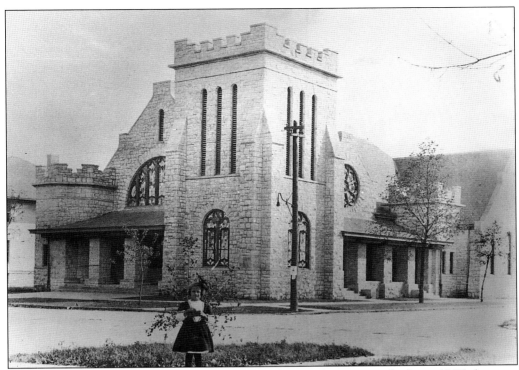
The First Baptist Church at 34th Street and Clinton Avenue was built in 1905, but was destroyed by fire in 1978. The structure was rebuilt on the same site.

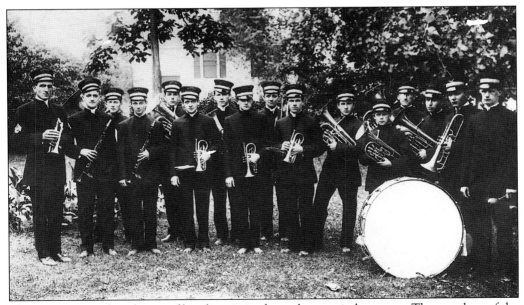
There was a virtual explosion of band music in the early twentieth century. The members of the Berwyn Brass Band posed in their uniforms before a 1909 performance. They played patriotic music, ragtime, and operatic medleys for dances, political rallies, and outdoor concerts.

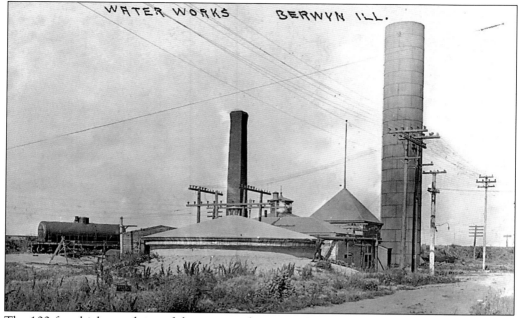

The 100-foot high standpipe of the waterworks on Wesley Avenue, seen in this 1908 postcard view, served as a landmark for generations. It can be seen in the distance on page 21 (top).

Louis and Warren Ritzma propel a three-wheeled cart down the wooden sidewalk by their home at 3220 East Avenue. Their father often shot weasels and 'possums that lived beneath the planks with his shotgun.

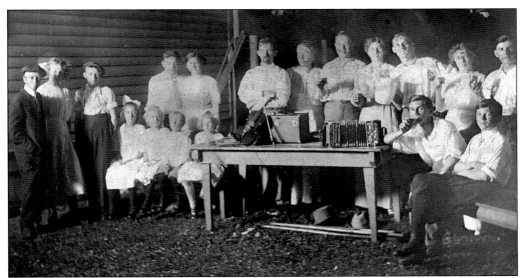

By 1900, so many Czechs resided in Chicago they nicknamed their city "Czech-ago." Most settled in the tenements of the crowded Pilsen neighborhood on the near Southwest Side. They gradually drifted into the Lawndale district before beginning their migration along the westward arteries of 22nd and 26th Streets into north Berwyn. Note the musical instruments on the table in this photo of a Berwyn Bohemian get-together from 1916.

Lots of families in early Berwyn kept chickens, geese, and cows in their yards. It was common to be awakened in the morning by one's neighbors' roosters crowing. Managing the family's hens and controlling the income from their eggs was usually the wife's job. Eggs sold for a penny a piece.

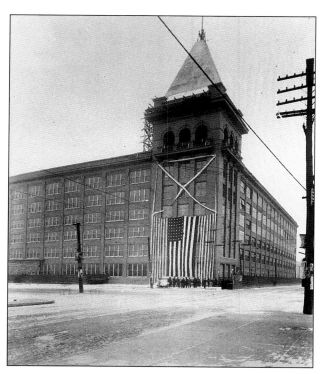

The massive Western Electric Hawthorne Works, a sprawling industrial complex at Cicero Avenue and 22nd Street, provided steady employment for many thousands of Berwynites. So many Czechs worked here the plant was dubbed "Bohemian University." This "city within a city" had its own railroad and fire department, a hospital, and a gymnasium. Twenty-two-year-old Berwyn architect Charles M. Prchal (1896–1980) designed the 183-foot tower, seen here still under construction, which contained executive offices, meeting rooms, and a dining room. The structure was demolished in 1987. A shopping center now stands on this site.

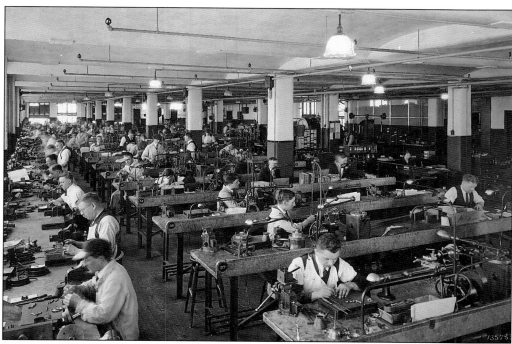

The Hawthorne Works, the manufacturing arm of AT&T, produced all the telephones used in the Bell system. Note the formality of the men's clothing on the shop floor (ties and vests, covered by protective aprons), indicating the stricter dress codes of the 1910 era.

Although immigrants often had to pack all they owned into a single cardboard suitcase, many Czechs, Slovaks, Serbs, and Poles proudly brought their ornately embroidered costumes with them. Many young people, however, were eager to abandon their old ethnic ways, to speak English without an accent, and to acquire American manners and habits.

The term bungalow was derived from the name for the one-floor cottage in the Bengal province of India that natives called *bangla* or *bangalo*. The simple, versatile, affordable style of residence would become the dominant form of housing in Berwyn. This early bungalow at 3220 East Avenue, seen here in a 1910 postcard, is still occupied by family members of the original owners.

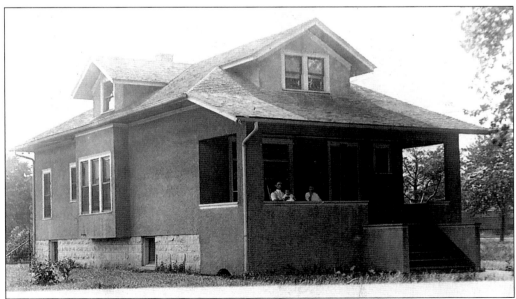

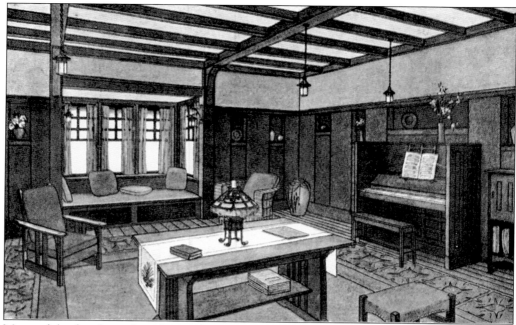

Many of the first bungalows featured "Arts & Crafts" interiors in which the walls and ceilings were divided into rectangles by wide oak trim. During the 1910s, people began to call their parlor a "living room." Heavy oak Mission furniture, enormously popular, was a rebellion against the fussy, fragile Victorian décor of the previous era.

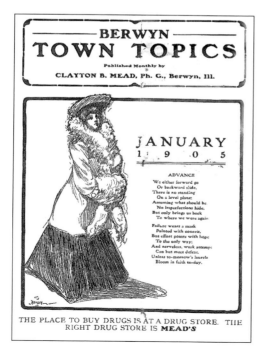

Clayton B. Mead, a Berwyn pharmacist, printed his own monthly newsletter, complete with jokes, cartoons, and community events.

This 1914 postcard shows one of Berwyn's great "lost buildings," the Berwyn State Bank on Windsor Avenue, a Prairie style structure designed by the architectural team of Thomas Talmadge (1876–1940) and Vernon Watson (1878–1950). Arthur Dunham (home below) was the vice president and stockholder of the bank.

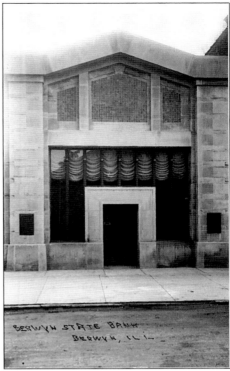

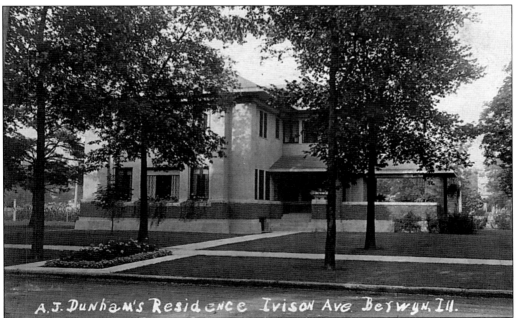

The Arthur Dunham House, (1906), seen here in a postcard view shortly after its completion, was built on four lots at 3131 Wisconsin Avenue. Designed by the firm of Talmadge & Watson, the home featured an attached garage, a unique feature for the time. This Prairie School residence is the only Berwyn residence on the National Register of Historic Homes.

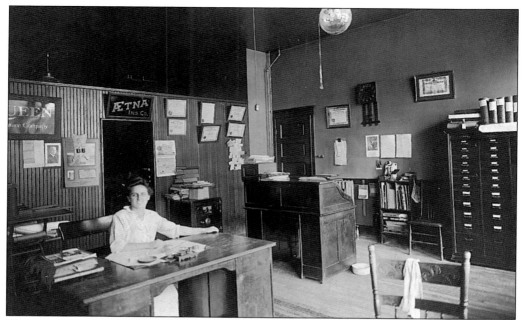

Women were entering the workforce in increasing numbers by 1910. Office work paid better than factory jobs, domestic service, or clerking in stores. Here Nelly Kelly is working in her family's real estate office on Roosevelt Road just east of Oak Park Avenue. "Heaven Will Protect the Working Girl," a popular song of the day, reflected how the previously sacrosanct male business world was being engulfed by a wave female office workers.

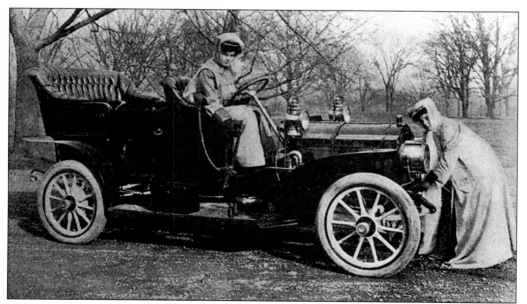

The automobile changed American life more than any other technology in the early twentieth century. Cars helped create a whole new suburban world. Previously, the population had to cluster around streetcar and elevated lines. These women drivers are struggling with the hand-cranked starter of an auto, c. 1908.

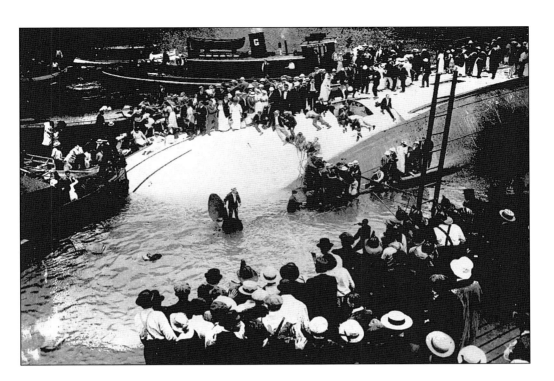

Berwyn was plunged into mourning on July 24, 1915, when the *Eastland*, a steamship chartered for a Western Electric company excursion in Michigan City, Indiana, rolled over on its side at 7:23 a.m. in the Chicago River at Clark Street, trapping everyone inside below the water line. It is now believed that the tons of extra lifeboats required after the sinking of the Titanic three years earlier made the *Eastland* top-heavy.

Twenty-two entire families were wiped out, and 844 people were killed. The majority of the victims were young people, including many children. Hardly a Berwyn family was untouched by the *Eastland* tragedy. When the Hawthorne Works reopened on Thursday, July 29, 1915, on one bench where 22 women had worked, only two had survived.

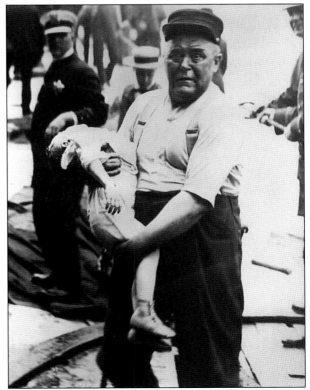

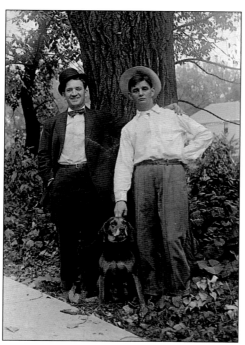

Frank Flood and "Musty" Owens, roommates in a boarding house on Ridgeland Avenue, pose with their dog Teddy in this 1914 postcard image. To help make ends meet, many families rented rooms, meals included, all for $2 or $3 per week. A multi-course supper served family-style encouraged one's "boardinghouse reach."

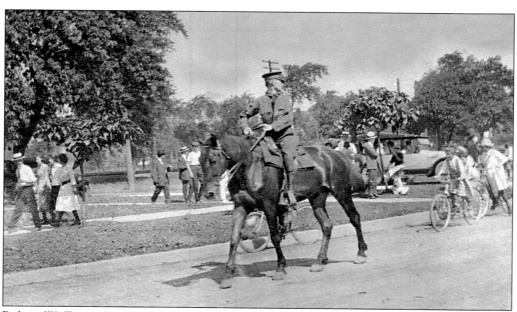

Robert W. Teeter (1885–1973) was a Berwyn businessman and civic leader who came to be known as "Mr. Berwyn." No single individual did more to make Berwyn an American city than Teeter. Seen here on horseback during the Fourth of July parade in 1918, Teeter was director of physical education at Morton High School. In 1911, he organized the first Boy Scout troop in the region. He founded the Berwyn Kiwanis Club and the Community Concert series. He built the Auditorium (Roxy) Theater, founded the Berwyn State Bank, and helped establish the Berwyn Park District, the Berwyn Library Board, and the Berwyn Recreation Board.

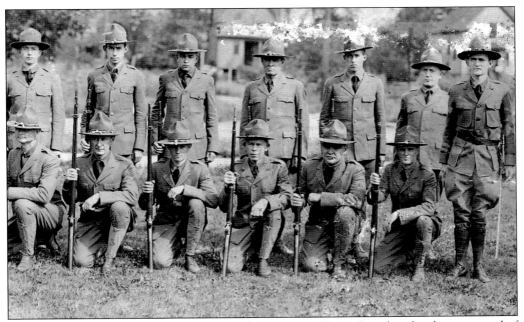

World War I brought about the formation of the Berwyn Home Guard under the command of Captain Robert W. Teeter, 3111 Wisconsin Avenue. Eighty-eight men with family deferments were rigorously trained, drilled, and inspected. This "home militia" was also used for riot duty on Chicago's South Side during the brutal racial conflict in July 1919.

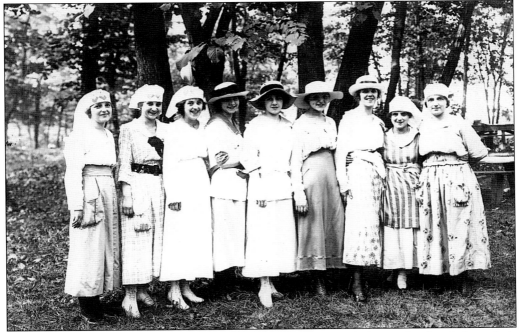

Patriotism ran high during the First World War. These Berwyn ladies took a break from their bandage-rolling and other war work for a picnic in late August 1917.

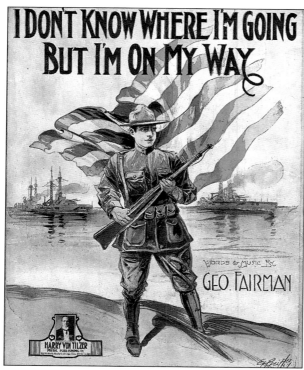

Sheet music of the World War I period from the archives of the Berwyn Historical Society shows how people embraced the war against the Kaiser in a flush of patriotic ecstasy. In November 1918, the United States emerged from the First World War as the champion of world democracy.

Before Berwyn set aside park areas, families often gathered for Sunday picnics along the perimeters of the 225-acre Gage Farm tree nursery, as can be seen in this 1920 snapshot. During the 1950s, both Cermak Shopping Plaza and Morton West High School would be located on a section of Gage Farm running from 22nd to 26th Streets, north of Riverside Drive.

Three

"WISH YOU WERE HERE"

Today we think of writing postcards as strictly a vacation ritual. We jot a few lines on the backs of scenic views to brag about our trip while we show friends and family they're not forgotten. But picture postcards were used quite differently in the early twentieth century.

Cheap, efficient, and speedy, they were the e-mail of their day. A penny postcard cost only another cent to mail. Postcards could provide a quick hello, a birthday greeting, or a get-well-soon. "Fred and I will be over Friday night for pinochle," Mae wrote to Sophie in 1922, "and I'll bring banana pudding." "Father's lumbago is acting up again," Emil informed his sister Frieda in 1913.

Berwyn residents took such pride in their city they especially loved sending family and friends new picture postcards of favorite landmarks and street scenes.

Postcards became so popular that drug stores began providing revolving racks to allow customers to wait on themselves. Berwynites could choose from scores of different local views whenever they "dropped a few lines" to one another.

Before long, amateur photographs could have picture postcards made at the drug store from their own Kodak film. Such "snapshot postals" became a popular way of sharing informal family pictures.

Although Berwyn was never considered a tourist attraction, there were hundreds of postcards of the city sold in the first third of the twentieth century. Many of these vintage images are now highly prized by collectors.

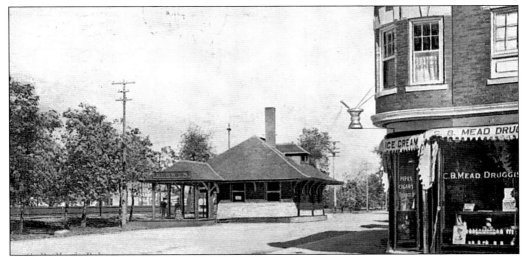

There were many postcard images of the Berwyn train depot sold over the years. When this one was mailed in 1909, there were separate waiting rooms for men and women, since most ladies found men's cigar smoke annoying and offensive. Note the mortar and pestle sign (right), indicating a druggist was on the premises at the Mead Pharmacy. (See page 40, bottom.)

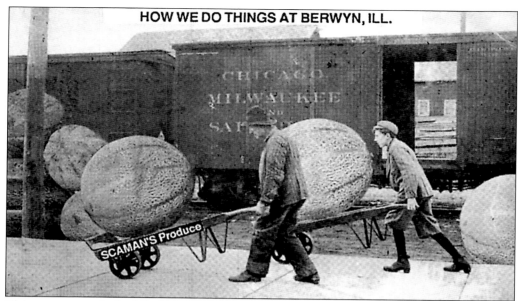

HOW WE DO THINGS AT BERWYN, ILL.

This gag postcard playfully boasts about the giant cantaloupes supposedly harvested in the marshy melon groves of south Berwyn, c. 1910.

Picture postcards featured views of nearly every neighborhood in Berwyn. Baldwin Avenue, named after the "father" of LaVergne, Thomas F. Baldwin, was renamed Wesley Avenue in the 1920s. The home on the left, 6639 31st Street, now has an enclosed front porch.

This 1910 view shows 6710–6712 34th Street looking east from Euclid Avenue. These homes are still standing, but the pointed roofs were removed many decades ago.

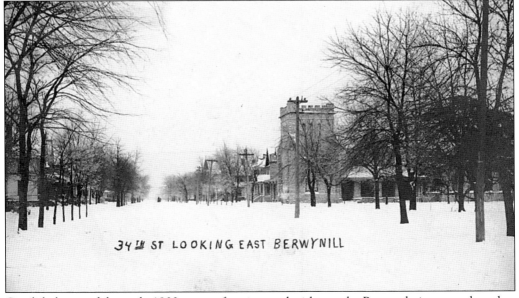

34TH ST LOOKING EAST BERWYNILL

Candid photos of the early 1900s were often jammed with people. Postcard views, on the other hand, were usually photographed just after dawn, before the streets were crowded with wagons, autos, or pedestrians. This wintry view from 1908 looks east on 34th Street from Home Avenue. Note the First Baptist Church on the right side of the street.

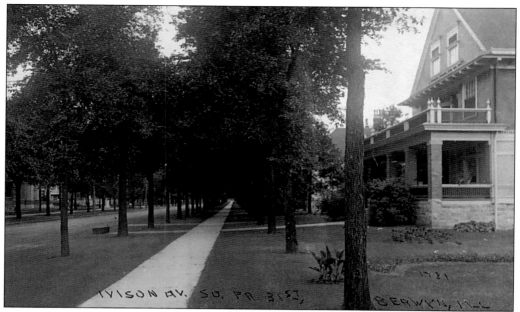

Ivison Avenue was renamed Wisconsin Avenue in the 1920s. The home on the right, 3110 Wisconsin Avenue, has a wide, open balcony on the upper level above the front porch.

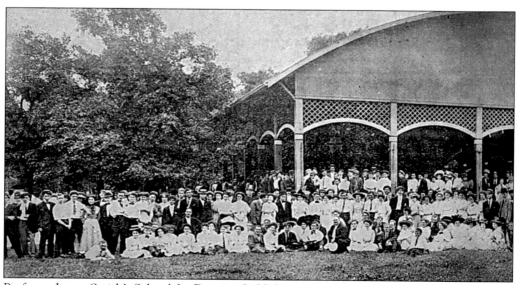

Professor James Smith's School for Dancing held their annual summer "Picnic Basket Outing" at the dance pavilion near 39th Street and Harlem Avenue in July 1912. Such summer events were considered perfect occasions for single young ladies to meet potential beaux.

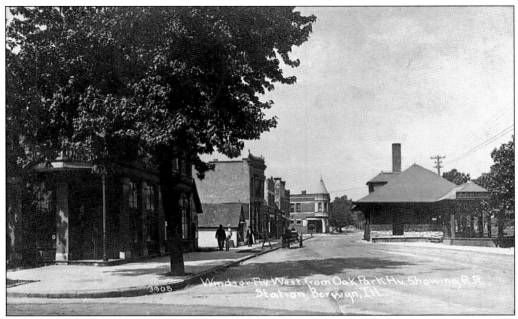

Looking west from Oak Park Avenue, this postcard shows the railroad station in the distance. In the early days, founders Piper and Andrews used a portion of the depot as their real estate office. The Berwyn Historical Society was formed in 1979 when concerned citizens mobilized when the historic structure was endangered. The building was saved and subsequently restored.

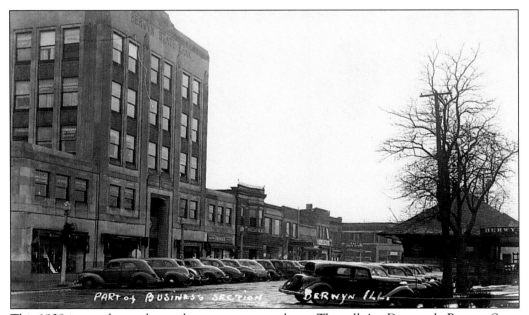

This 1939 image shows almost the same scene as above. The tall Art Deco style Berwyn State Bank had failed shortly after it opened early in the Depression. The train station had been moved closer to the tracks to widen Windsor Avenue in 1917.

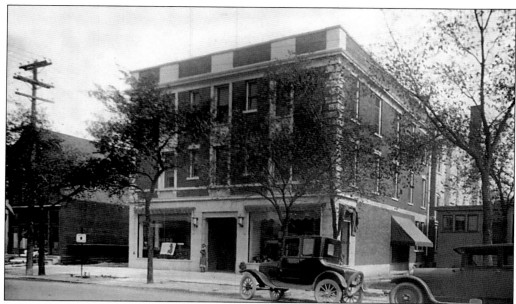

Dr. Arthur W. MacNeal, a graduate of Rush Medical School, came to Berwyn in 1892 at age 24. He opened his practice in his own home, calling it the Berwyn Medical Unit. He was one of the first doctors to use a breakthrough diphtheria vaccine, and he had one of the first x-ray machines in the county in 1902. This 1920s postcard shows MacNeal's hospital in its first of many expansions. The electric car (center) is Dr. MacNeal's, used for house calls.

This postcard, mailed to "single gents" in 1913, urged them to attend a 25-cent picnic given by the North Berwyn Club in a grove on Harlem Avenue just south of 12th Street. In addition to a live band providing music, there was a box lunch raffle. Each bachelor spent the afternoon in the company of the young woman who had prepared the lunch he bid on and won.

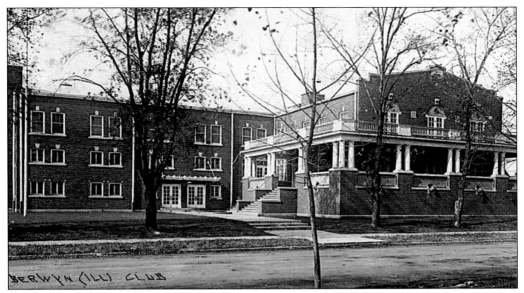

The L-shaped Berwyn Club, 3308 Oak Park Avenue, cost $60,000 when it was constructed in 1912. The building was a hub of social life until it was razed to make room for a National Tea supermarket and a bank in the early 1960s.

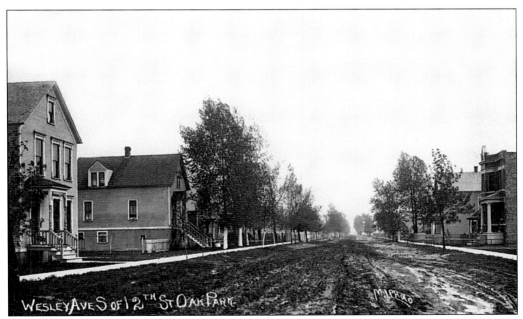

Wesley Avenue just south of 12th Street (Roosevelt Road) was often impassable following heavy spring rains. Note the caption identifying this vicinity as "Oak Park." Residents of the northern zone of Berwyn sent their children to Oak Park schools and received mail addressed to "South Oak Park."

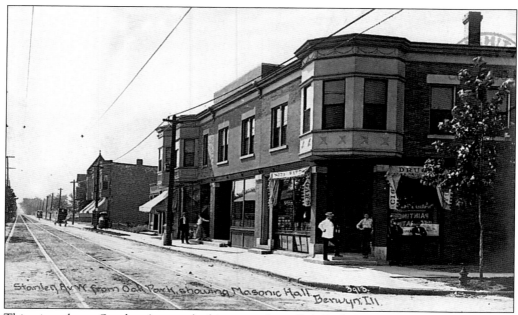

This view shows Stanley Avenue looking west from Oak Park Avenue, *c.* 1907. Just west of the center awning is the combo bakery and café seen on page 28. The street is unpaved, yet streetcar service was efficient and well used. Note the same location two decades later below.

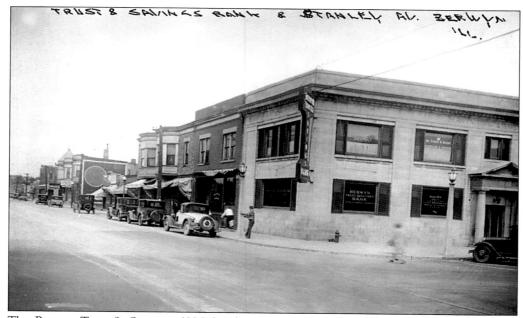

The Berwyn Trust & Savings, 6896 Stanley Avenue, *c.* 1928, replaced the corner storefront above, but like all financial institutions in the city, it collapsed in the early 1930s. Today, the structure is endangered by condo development. Other banks that failed in the Depression were adapted, such as the Ridgeland State Bank, 2600 Ridgeland Avenue, which became the Cicero-Berwyn Elks Club.

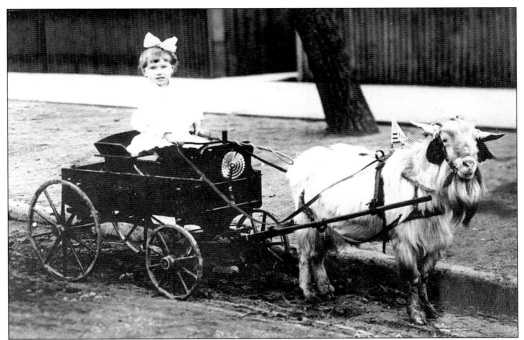

Through an aggressive ad campaign, the Eastman Kodak Company made taking "snapshots" a normal part of family life. Kodak convinced the public that photography was now so easy "even a child can do it." A Brownie camera cost a dollar. Postcards like this one of a child in a goat cart, c. 1915, could be made at the drugstore.

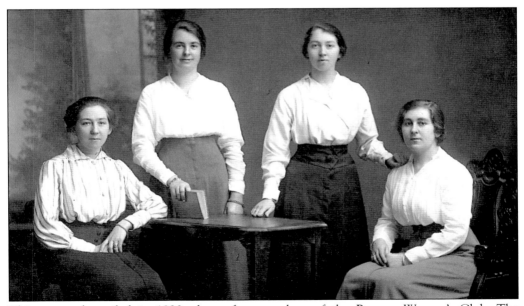

This postcard, mailed in 1920, shows four members of the Berwyn Woman's Club. The organization promoted civic betterment and philanthropic work. The ladies sought to assist those in need, such as newly arrived immigrants, destitute women, and neglected children.

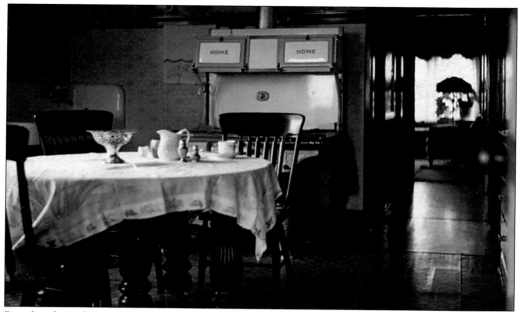

People often photographed their new homes, then mailed the views out to family and friends still living in the city, urging them to "come on out to Beautiful Berwyn!" This is the kitchen of the A. Krasinger family, 1643 Kenilworth Avenue, in 1925.

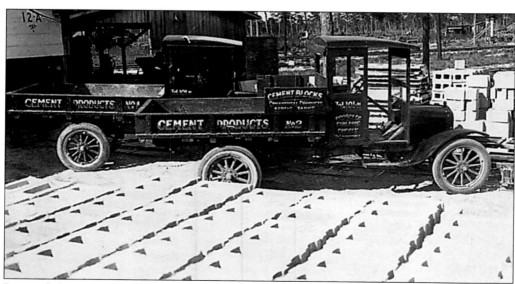

Postcards began to be used for advertising purposes in the 1910s. John Kelly's "Block Brick Factory" was located on Harlem Avenue between 13th and 14th Streets, c. 1913. Many of the new homes constructed during Berwyn's building boom would use Kelly's concrete blocks.

Pearl Yurka and Joseph Kubik were sweethearts who mailed this postcard to friends and family to announce their engagement in 1923.

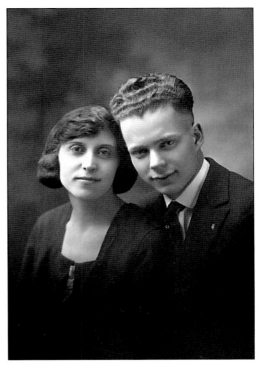

Though many careers were closed to women, working class and immigrant daughters did not have the luxury of remaining idle. This young "flapper," Marie Krupka, was a stenographer at the Hawthorne Works in the 1920s.

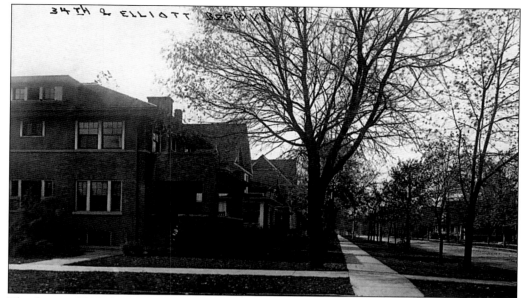

This home, 6822 Grove (formerly called Elliott) Avenue at 34th Street, shows the cement sidewalks and thriving elms that attracted many new residents to the picturesque suburb. Berwyn was evolving into a unique mix of blue-collar workers and the rising new middle class. This latter group was composed of salaried professionals, managers, shopkeepers, and office workers.

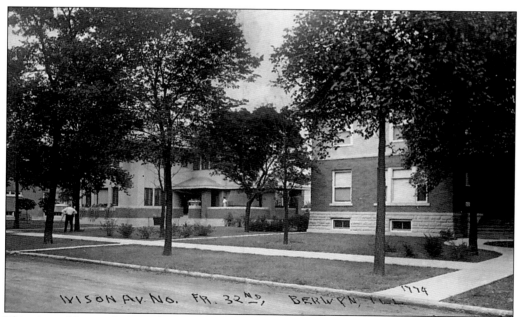

This view of Ivison Avenue, later renamed Wisconsin Avenue, just north of 32nd Street, shows the Arthur Dunham house (page 41) on the left and 3137 Wisconsin Avenue on the right.

Four

THE BUNGALOW BOOM

During the 1920s, the small farms and vast prairies of central Berwyn were subdivided. Thousands of new homes—mostly bungalows—were quickly constructed. The improved roads and centrally located city government helped unify the booming community.

Berwyn continued to be deluged with newcomers, many of them Czechs coming from the Pilsen and Lawndale neighborhoods of Chicago. These hard-working people shared a strong socioeconomic status that enabled them to engage in significant real estate transactions and building projects.

Despite the unprecedented construction boom, municipal building codes were rigidly enforced, which accounts for the solid, well-preserved housing stock of present-day Berwyn.

The phenomenal growth of Berwyn during the 1920s is reflected by the census figures. When the 1920 census was taken, the population was 17,000. In 1930, the community had grown to 48,000.

Entire blocks were built at once, with contractors digging all basements simultaneously. Next came crews to lay foundations, followed by carpenters, bricklayers, plasterers, plumbers, and electricians.

The commercial community thrived, too. Berwyn became a bustling suburb with four movie theaters, specialty shops, chain stores, paved streets and traffic jams. Each bungalow needed a garage to house the family's new automobile.

In 1929, there were 43,000 workers on the payroll of Western Electric's Hawthorne Works, the area's major employer.

But the bottom dropped out when the stock market crashed. The decade of the 1930s brought very hard times. All the banks in Berwyn failed, often taking depositors' life savings with them. Mortgages were foreclosed. Yet many residents found work in federal New Deal" programs like the WPA and the PWA.

World War II brought bond drives, rationing, Victory Gardens, patriotic parades, and a massive draft. Nearly every Berwyn family had someone in uniform.

Berwyn Manor and Berwyn Gardens were two popular bungalow subdivisions. This 1925 postcard shows Maple Avenue looking north from 31st Street. While accommodating a large migration of Czechs and Bohemians from Chicago, these new neighborhoods helped define the city of Berwyn as a major enclave for persons from Eastern Europe.

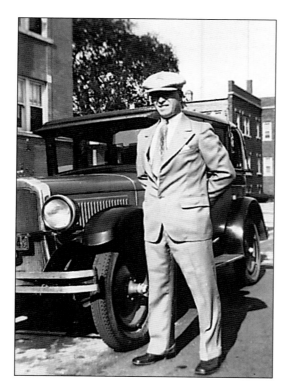

During the 1920s, amateur photographers increasingly used a new prop in their pictures: their single most prized possession—their automobile. Seen here in front of 6513 21st Street is one family's brand new 1924 Oakland.

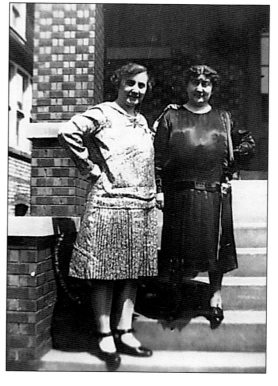

By the 1920s, many families were documenting their lifestyles with a Kodak "box camera." The snapshot made possible an informal photo in which the subjects appeared more relaxed than in studio portraits. Wearing the drop-waist styles of the flapper era, these two neighbors enjoy their morning chat on the stoop at 1925 Wisconsin Avenue.

This bungalow bathroom, c. 1924, has a white ceramic toilet, a pedestal sink with hot and cold "taps," a shower, and a medicine cabinet with a mirror. Gone is the claw-foot tub of the early 1900s.

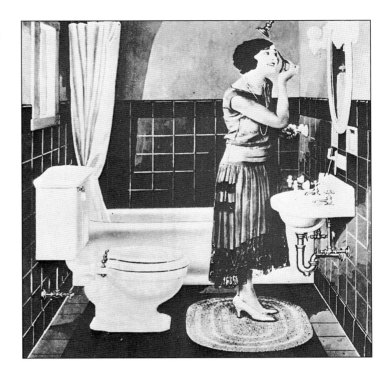

Thousands of bungalows were constructed where onion fields and cabbage patches previously existed. These homes were well laid out to accommodate growing families. There was also a wide range of style, depending on the budget of the owners. Some homes had sparkling leaded glass windows, for instance. Others had clay-tile roofs. This 1925 photo shows the house at 3340 East Avenue.

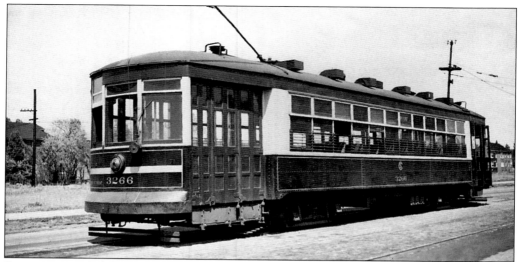

Streetcars traveled through Berwyn from 1896 to 1948. The Cermak Road trolley ran down the middle of the street. On weekends, the easy-access, cheap transportation encouraged people to go on country outings and picnics, attend concerts, or visit the cemeteries. The conductor rang the bell, made change on the rear platform, called out streets, and issued transfers. In the winter he also tended the pot-bellied stove.

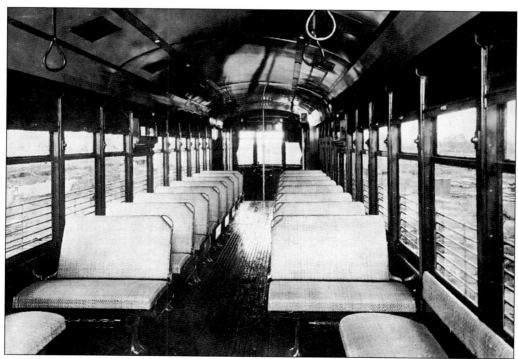

As the streetcar lines made daily commuting into the Loop easy and affordable (nickel fares with free transfers), central Berwyn rapidly filled in with homes. Trolleys not in use were housed in the "car barn" at Harlem Avenue and Cermak Road where Rizza Ford is now located.

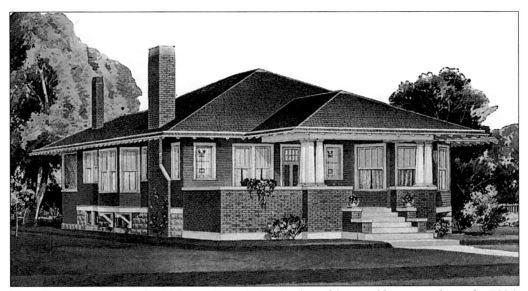

This illustration is from the 146-page Sears & Roebuck prefabricated home catalogue for 1926. Numbers on the blueprints corresponded to the numbers on the pre-cut lumber and millwork. Many Sears homes could be constructed in an eight-hour day. The Berwyn Historical Society has documented at least a dozen "Sears homes" in the community.

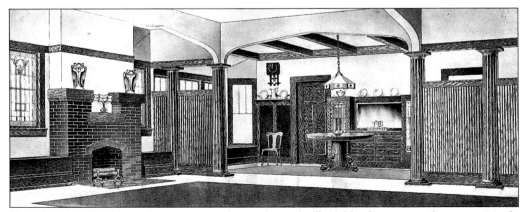

Sears "mail order homes" were not only sturdy and affordable, but were often surprisingly charming. Hearths even came with artificial gas logs. This model cost $1,235, which included all building materials, blueprints, plans, and instructions.

In 1925, Frank Janda became Berwyn's first Czech mayor, illustrating the rising influence of Czechs politically in the community. In 1934, of the 220 Czech-Americans listed in the "Czech Who's Who," 15 percent lived in Berwyn. Frank and Marie Janda lived at 1805 Scoville Avenue. During Janda's two mayoral terms, Berwyn became a town of paved thoroughfares and alleys. At that time, the names of "south end" streets were also synchronized with north Berwyn.

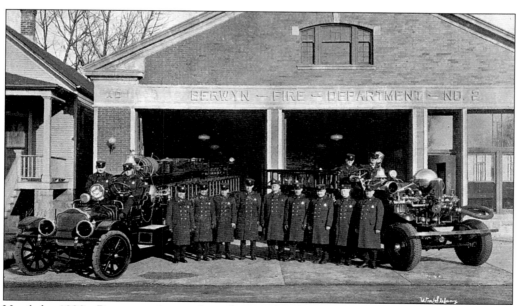

Until the 1920s, Berwyn maintained a volunteer fire department. This 1925 photo shows the 16th Street Fire Station, between East Avenue and Clarence Avenue. The house (left) and fire station are both still standing.

The Berwyn Style Shoppe, 6509 22nd Street (Cermak Road), sold the latest fashions to the flapper set. These silk crepe summer frocks were going for $4.95 in 1926. Young women rejected the tight corsets and long skirts worn by their mothers.

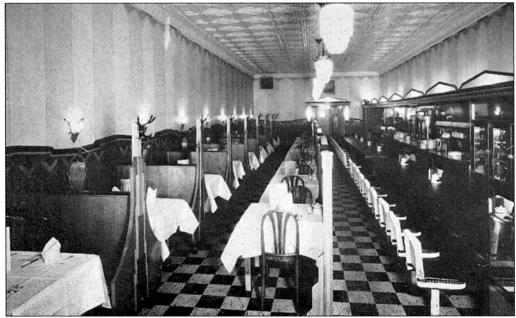

Latzel's Restaurant, 6734 Windsor Avenue, near the train station, was known for quick service and "cheap eats." In 1929, one could purchase chicken fricasse or roast pork with applesauce for 20 cents, and a slice of rhubarb pie for a nickel.

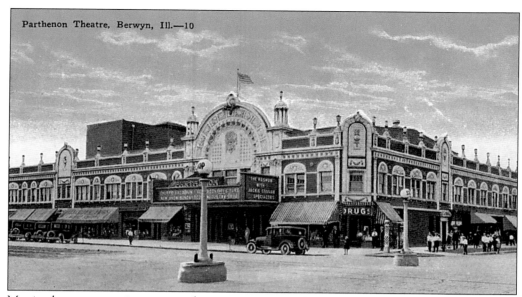

Movies became a major source of entertainment in the 1920s. There were four theaters in Berwyn. The Parthenon, seen here in a 1924 postcard view, once stood on the corner of Ridgeland Avenue and 22nd Street. A giant pipe organ and a full-scale orchestra replaced the tinkling piano of the nickelodeon era. The theater, with a seating capacity of 2,200, was lavishly decorated with tapestries, murals, oil paintings, and oriental carpet.

The Parthenon Theater featured both silent movies and vaudeville shows. The popular dance team of Oakes & LeTour, headliners on the Orpheum Circuit, often "closed the top half of the bill," a key position in the line-up of performers. In the 1930s, vaudeville was killed off by talking pictures, radio, and the Depression.

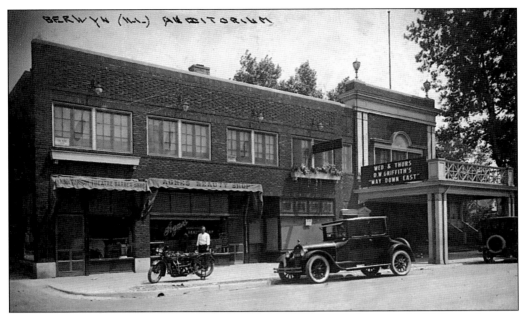

This early 1920s postcard shows The Auditorium, a silent movie theater at 3245 Grove Avenue. The film on the marquee is D.W. Griffith's melodrama, *Way Down East*, starring Lillian Gish.

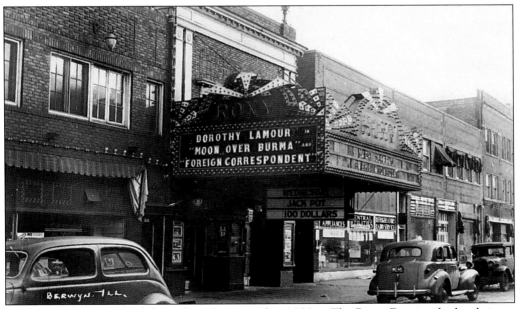

The same theater, rewired for "talkies," reopened in 1930 as The Roxy. Despite the hard times, people flocked to The Roxy to escape the Depression. When this view was taken in 1940, The Roxy offered a double feature (a musical comedy and an Alfred Hitchcock thriller), plus a cartoon, a newsreel, and a short subject for 25 cents. The management also gave away dishes on Thursday nights.

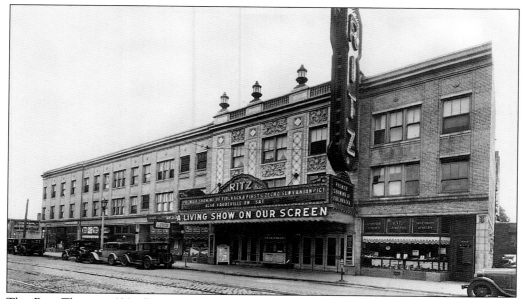

The Ritz Theater, 6334 Roosevelt Road, offered both movies and live entertainment. The vaudeville bill usually included jugglers, magicians, singers, comedians, and chorus girls. Charleston dance contests were held on stage during the height of the fad. Czech films were routinely screened, too.

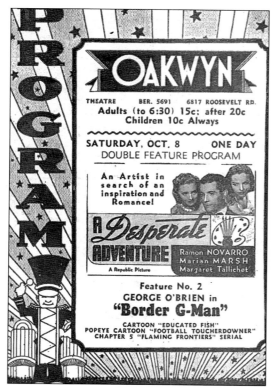

Movies provided much needed escapism. Many Berwynites went to the show several times per week. This 1938 "promo program" from the Oakwyn Theater, 6817 Roosevelt Road, plugged several weeks of upcoming features. The Oakwyn was the first of Berwyn's movies houses to fall victim to television in the early 1950s, although the building survives as a union hall, Teamsters Local #714.

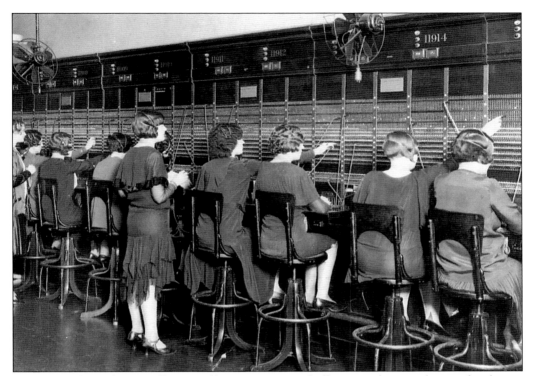

This 1929 photo showing Illinois Bell operators at work illustrates the complexity of making a simple call in the days before direct dialing. Most Berwyn residents owned telephones, although many families shared a "party line." The Bell Company advised: "When you wish to place a call, remove the receiver and listen. If the line is in use, politely restore the receiver to the hook and wait for those using the line to finish."

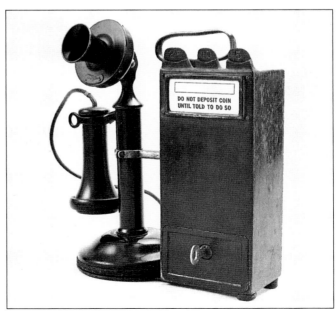

Stand-up "candlestick" telephones were much more convenient than wall-hung models. This particular coin-operated "pay phone," c. 1922, was manufactured at the Hawthorne Works plant. It could be brought to one's table in restaurants, clubs, and speakeasies.

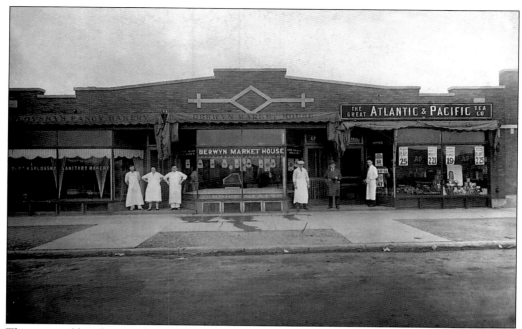

The aproned butchers at the left worked in a "meat market" next door to the Atlantic & Pacific Tea Company (commonly called the A & P), a grocery chain that originally sold only teas, coffee, and spices. There were 11 A & P stores in Berwyn in the 1920s. This one was located at 6711 26th Street.

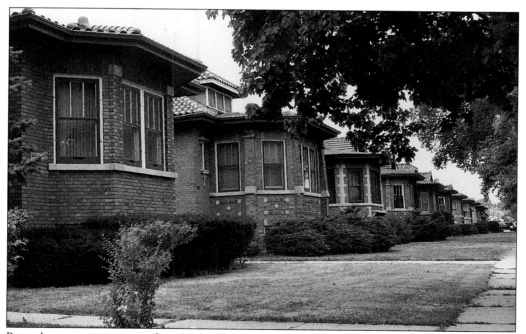

Bungalows were constructed on 30-foot lots with a narrow "gangway" between and a garage on the alley in the back.

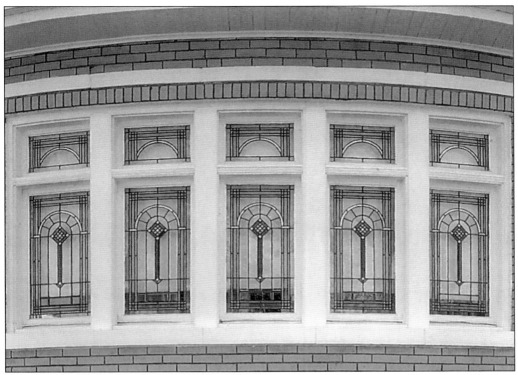

Bungalow builders offered many possible stylistic variations, depending on the taste and budget of the homeowners, from Mediterranean tile roofs to art-glass bay windows.

The screened-in porches on the backs of many bungalows were often utilized for sleeping on hot summer nights.

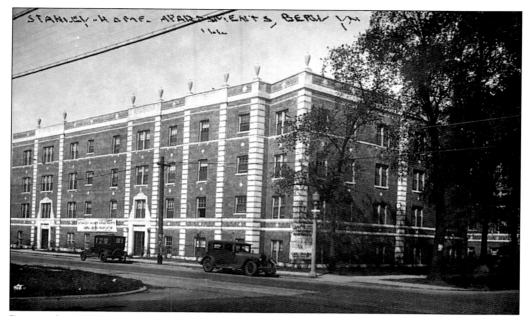

During the 1920s, many brick apartment houses were built within walking distance from the trains and streetcar lines. Few apartment dwellers owned automobiles. This postcard, mailed in 1926, shows one of Berwyn's classy new "courtyard" buildings, just north of the "Q" tracks at 3234 Home Avenue.

General Custer Grade School, 1427 Oak Park Avenue, was the first school in north Berwyn, erected in 1908. These 1925 eighth graders just appeared in a class variety show. The school was named for George Armstrong Custer (1839–1876) who was defeated by Sitting Bull in the Battle of the Little Bighorn (Custer's Last Stand). A new, state-of-the-art school erected on this site in 2002 was renamed Prairie Oak Elementary.

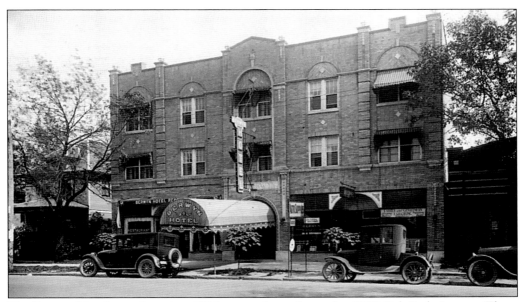

The Berwyn Hotel, seen here in a 1925 postcard, was located at 3139 Oak Park Avenue. There was a "tea room" that served chicken casseroles, omelets, and salads, plus a cigar stand in the lobby. The building, sans canopy and neon sign, still stands.

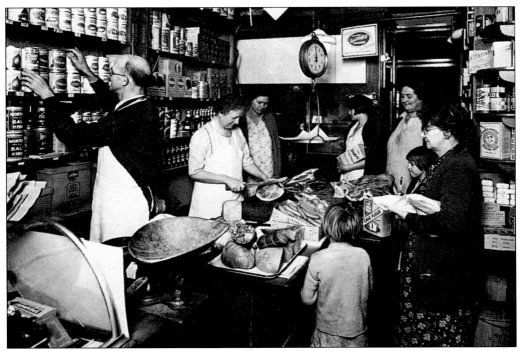

Small family-run grocery stores were located on the corners of most neighborhoods. Since few families had electrical refrigeration, housewives often shopped for food daily. Proprietors of these "mom and pop" stores knew customers' names and those of their children. After World War II, such small groceries experienced stiff competition from the large chain supermarkets.

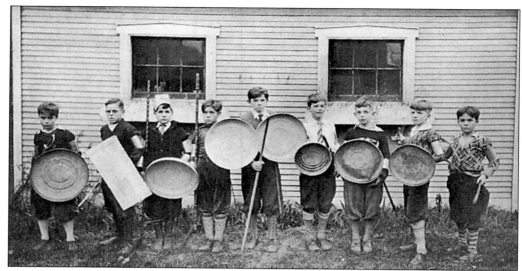

Alleys were popular playgrounds for boys. Favorite games included cops-and-robbers, kick-the-can, hide-and-seek, mother-may-I, and statue-maker. These kids are playing King Arthur and his Knights of the Round Table. Boys wore knickers until adolescence in the 1930s.

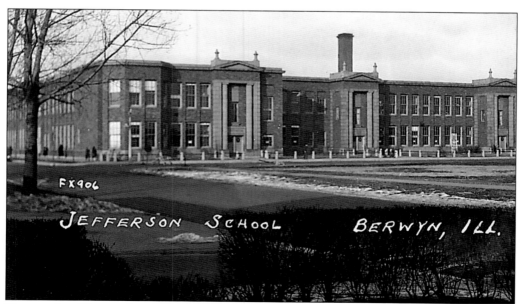

The people of Berwyn have always been justifiably proud of their schools. Many new buildings were added during the 1920s boom years. This one, Jefferson School, 7035 16th Street, was built in 1928. At the time this postcard was mailed in 1934, the average Berwyn public school teacher was paid $1,227 annually.

The ethnic community placed such a high priority on savings that for decades Berwyn school children participated in a weekly "Banking Day" program. Pupils turned in nickels and dimes that were recorded in their own pass books by their teachers. Deposits were sent to the office, then transferred to a real Berwyn bank. This 1920s postcard shows pupils at the new Piper School, 25th Street and Kenilworth Avenue, named for Berwyn founder Charles E. Piper.

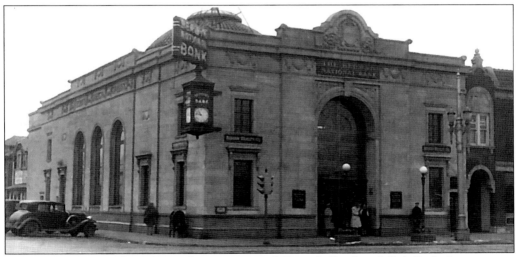

The Berwyn National Bank, southwest corner of Cermak Road and Oak Park Avenue, was built in 1926, a time when banks were supposed to look like Greek temples. Originally called the American State Bank, its solidly classical style symbolized pre-Depression prosperity. There were 24 teller cages that opened and closed with an electric switch and a tear gas bomb chamber. The decorative frieze around the top of the structure says "Security . . . Strength . . . Stability." The Beaux-Arts style dome resembles that of the Museum of Science & Industry. Now standing empty, the bank is designated one of Illinois' "Ten Most Endangered Historic Places" by the Landmarks Preservation Council of Illinois and is on the National Register Register of Historic Places.

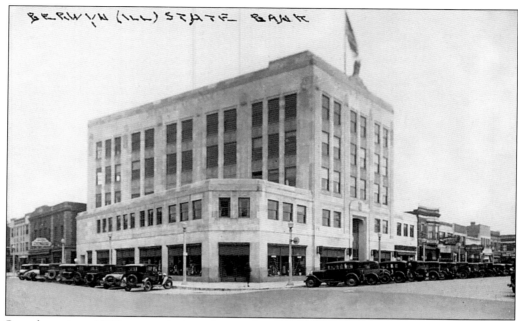

Seen here in a 1930 postcard view, the newly opened Berwyn State Bank at the corner of Windsor Avenue and Oak Park Avenue is composed of a series of staggered, step-like buildings in the Art Deco style. The formidable structure exhibits sleek, stylized "moderne" carving and ornamentation on its exterior, in contrast to the steer heads and classical cornices of the Berwyn National Bank (page 75).

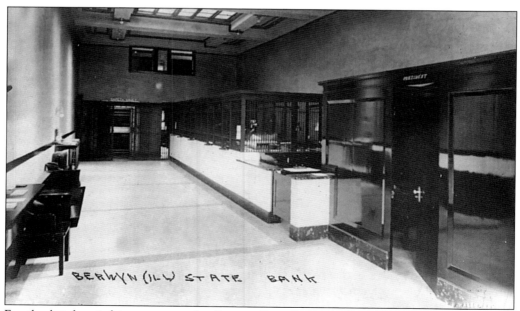

For the brief period it was open, the Berwyn State Bank made it possible to do business in everyone's native tongue. But the institution failed in early 1931. Today the "West Wing" branch of MacNeal Hospital is located in this building.

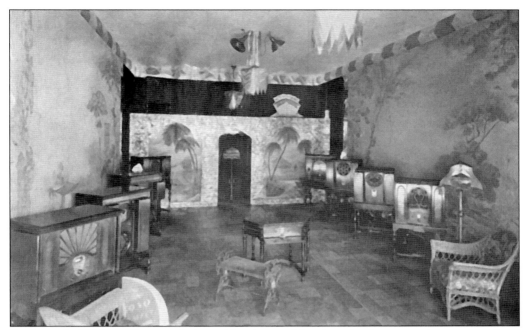

By the early 1930s, radios were being sold as items of furniture in elegant settings, as seen here at Berwyn's Electric & Radio Store, 6712 Cermak Road. Even in the depths of the Depression people continued to purchase radios.

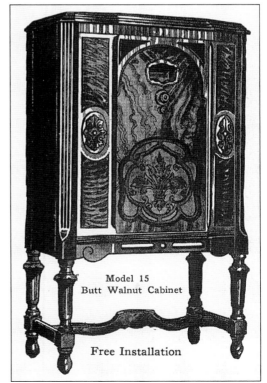

Model 15
Butt Walnut Cabinet

Free Installation

This seven-tube, walnut cabinet Brunswick console radio sold for $89.75 in 1931. Despite the hard times, few families defaulted on their radio payments. Every conceivable type of entertainment, from opera to swing music, from *The Shadow* to *Amos 'n Andy*, was available free via the airwaves.

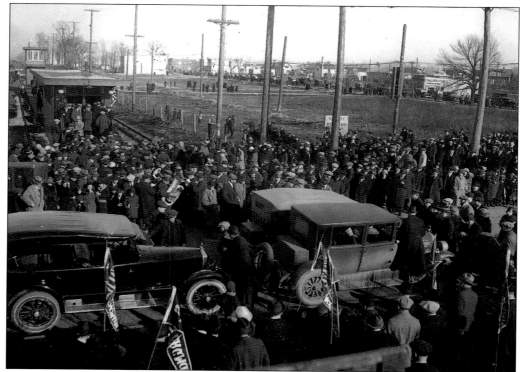

Jubilant crowds turned out in 1924 when a brass band rode the first Douglas Park "el" into Berwyn, getting off at its "temporary" Oak Park Avenue terminal. The elevated tracks, running at street level, were supposed to be extended to Harlem Avenue and beyond, but it never happened. Over the years, nine different railway systems serviced Berwyn, but none of them connected the north and south ends of the community.

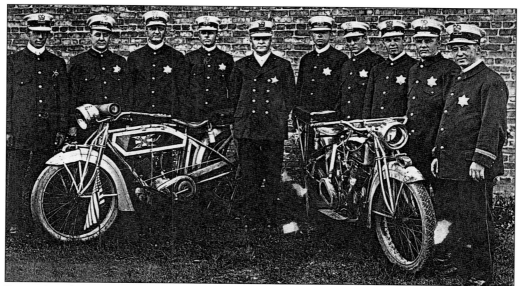

Berwyn's Police Department was equipped with new Excelsior Motorcycles in 1920.

The automobile not only allowed workers to commute to their jobs easily, it changed courtship habits and family lifestyles. This couple is on a picnic at Harlem Avenue and Pershing Road on Decoration Day (now Memorial Day), 1924. The holiday opened the picnic season. Labor Day concluded it.

In the 1920s, "filling stations" were often disguised to blend into their neighborhoods. This 2005 photo shows the castellated design and rough, red brick of a former gas station at 2211 Clarence Avenue, now an auto repair shop.

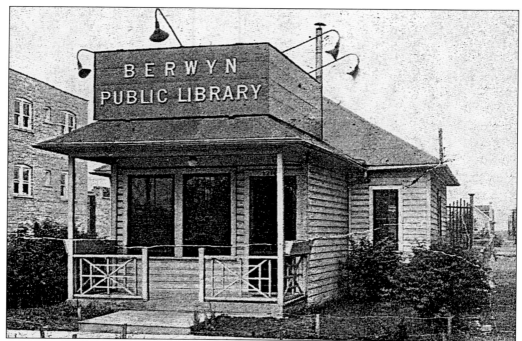

In 1926 the Berwyn Public Library was located in a former real estate office, 2218 Oak Park Avenue.

These youngsters are looking at the display of toys and games in the window of the F.W. Woolworth "dime store" located at 6816 Windsor Avenue in 1925.

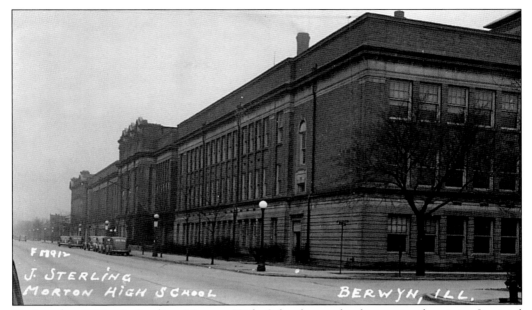

During the 1920s, J. Sterling Morton High School was the largest in the state. Its total enrollment of over 7,000 students from Berwyn-Cicero included the student body of Morton Junior College. Though this postcard indicates the school is located in Berwyn, the address was Cicero. Berwyn would not have its own high school (Morton West) until 1958.

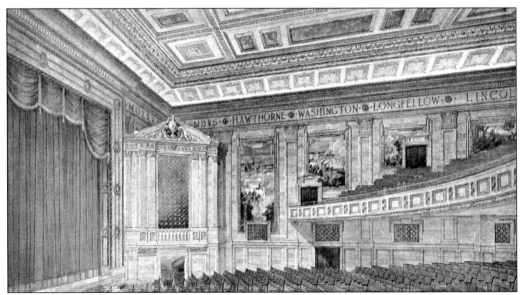

With a seating capacity of 2,545, the nearly acoustically perfect Chodl Auditorium was a popular place for community events as well as Morton High School productions. It was the largest high school auditorium and the largest non-commercial stage in Illinois. The stage, in fact, was big enough to serve as a regulation basketball floor. Theatrical productions were staged in the fall and spring when gym classes were held outside. The auditorium is now on the National Register of Historic Places.

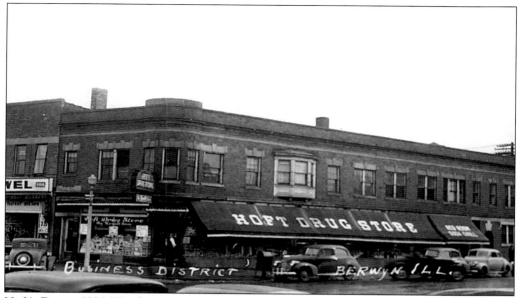

Hoft's Drugs, 6820 Windsor Avenue, is seen in this late 1930s postcard view. It replaced the Mead Pharmacy (page 47). Note the early storefront Jewel Food Store, 6818 Windsor Avenue, at the left.

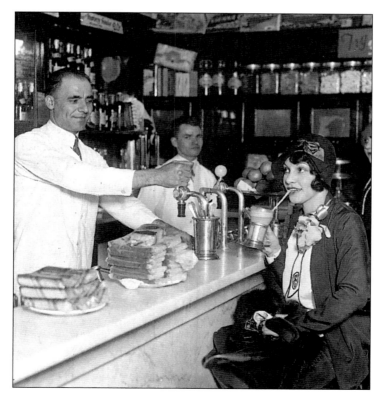

Drug stores were equipped with soda fountains in the 1930s. Hoft's Drugs was especially known for having tasty sodas and milk shakes.

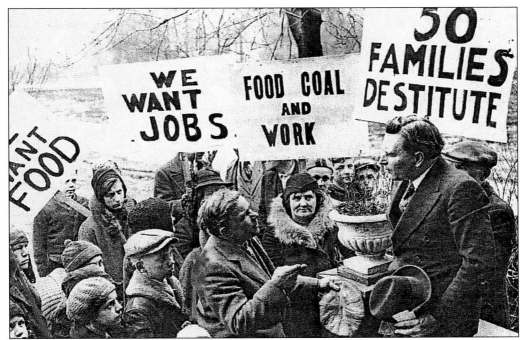

Reverend Henry C. Hoover of the First Congregational Church earned the title "Berwyn's Battling Pastor" in the 1920s and 1930s for his valiant crusades to rid the community of illegal saloons ("speakeasies") and organized crime. He fought Al Capone's "dives and dens of crime" during Prohibition. In this Depression-era photo, c. 1932, the idealistic clergyman listens to the concerns of Berwyn families struggling with the hard times.

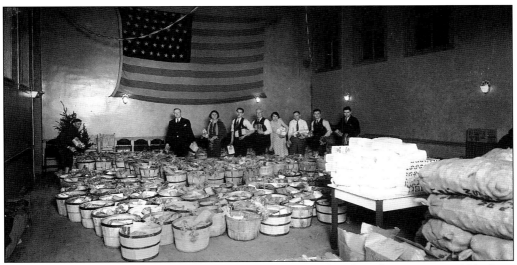

Berwyn was unable to cope with the rising number of unemployed residents. In May 1933, there were 1300 local families on relief. These baskets of groceries were distributed to the "100 neediest families" at Christmas that year. During the summer, food was grown at several public gardens at Cermak Road and Harlem Avenue. The large plots, tended by the unemployed, produced over 50,000 pounds of vegetables in 1933.

Berwyn parents were expected to give their children the "advantages" they had not enjoyed. Here, a group of 1929 dance students are rehearsing for a recital at Miss Edythe B. Rayspeis' Dancing School, 6801 Cermak Road.

These young men, posing with Mayor Frank Novotny on Boys' Government Day, May 17, 1933, are ready to assume their offices and "run the city" for the day.

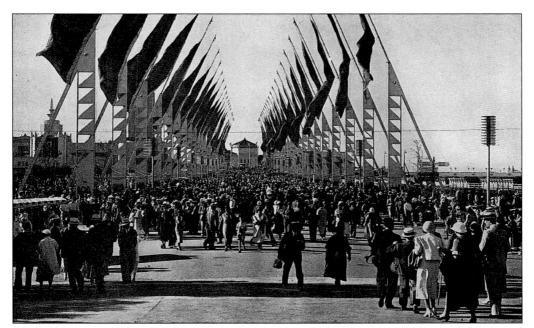

All local businesses closed at noon on September 22, 1933, so people could attend the special "Berwyn Day" festivities at the "Century of Progress" Chicago World's Fair. The first event was a parade down the Avenue of Flags, led by the 135-piece J. Sterling Morton High School Band.

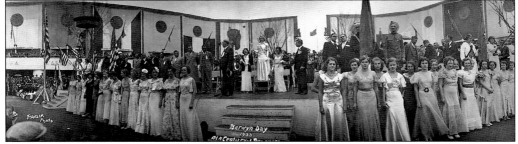

Miss Lillian Karaffa, 1328 Harvey Avenue, was chosen "Miss Berwyn 1933" from 40 finalists (see front cover). Lillian was crowned at "Berwyn Day" at the World's Fair, surrounded by her court and an assortment of Berwyn officials. Robert Teeter (page 44) played piano. A highlight of the day's events was a performance by the Berwyn Accordion Orchestra.

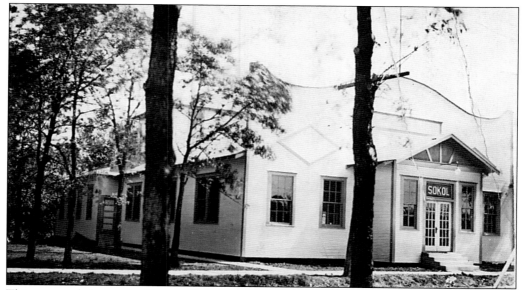

This postcard shows the Berwyn Sokol Hall, 6447 27th Place. When the Czechs settled in Berwyn they brought with them their fraternal centers known as Sokol Halls. These recreation centers held social events and taught gymnastics. They were established to help maintain both physical fitness and mental health.

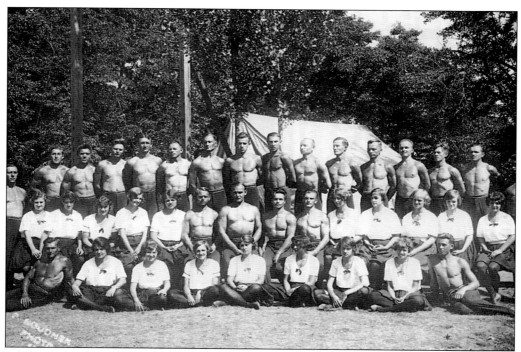

Sokol is the Czech word for "falcon," a bird known for its courage, endurance, speed, and sharp eyesight. It symbolized the ideas of the organizations: fitness, strength, and high moral ideals. Sokol camps, such as this one, were known for their gymnastic competitions.

While her husband Charles Prchal (1896–1980) was designing the Hawthorne Works Tower (page 38), Mildred Prochaska Prchal (1895–1983) became a solo dancer for the American Ballet Company, as well as one of the first women to join the ranks of the Sokol instructors. The Prchals lived at 2533 Oak Park Avenue.

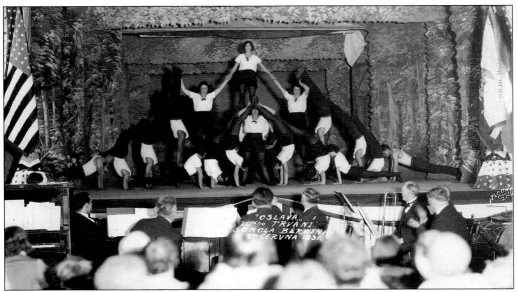

One began taking Sokol classes at age three. All classes were conducted in Czech. The premise was that a sound mind is easier to possess if you have a sound body. This Sokol gymnastic presentation, with an orchestra accompaniment, took place in 1931.

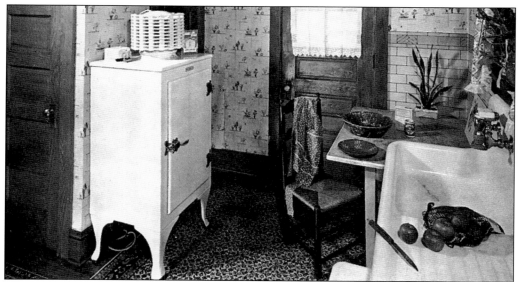

During the 1930s, although many families continued to use iceboxes, lots of other Berwyn residents purchased electric refrigerators that allowed them to store perishable food for longer periods. During the Depression, "hoboes" often appeared at the back door, especially near the Chicago, Burlington & Quincy tracks, asking to do chores in exchange for a sandwich or a dime.

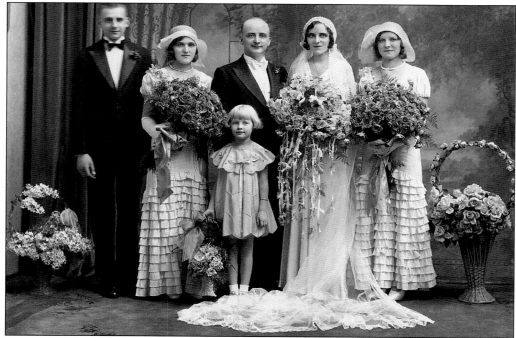

This studio wedding portrait from 1931 conveys a distinct sense of time and place. Following the ceremony at St. Mary of Celle, the bride and groom's family and friends enjoyed a traditional Czech wedding dinner. Women often spent days preparing Bohemian dishes, such as pork dumplings in dill gravy, rye bread, sauerkraut and pastries.

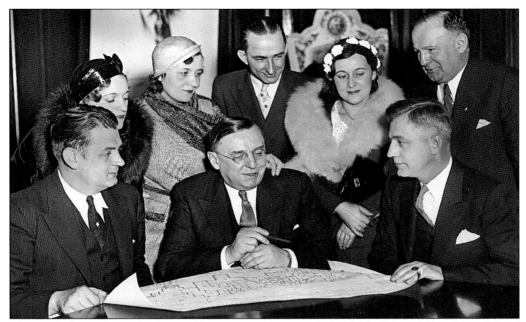

Chicago's first and only foreign-born mayor, Anton Cermak (1873–1933) was a shrewd politician who ran an efficient, well-oiled machine. Here Mayor Cermak (center), who always had a special fondness for Berwyn, chats with Mayor Frank Novotny (to the right of the lady with the white fox piece) and a delegation of other Berwyn officials in 1932.

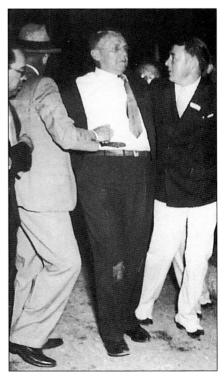

On February 19, 1933, Mayor Cermak of Chicago was killed by an assassin's bullet intended for President Franklin D. Roosevelt who was standing beside him at a political rally. Note his bloodstained shirt just above the belt-line and his soiled knee from falling. "I'm glad it was me and not you," were the dying mayor's last words to Franklin D. Roosevelt. Twenty-Second Street was renamed Cermak Road to honor the slain Czech-born politician.

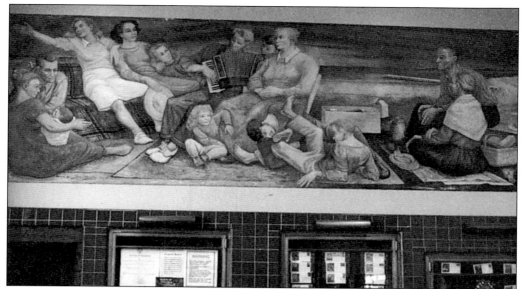

Between 1936 and 1942, the Federal government financed many artists to produce murals for public buildings that celebrated aspects of the American way of life. *In the Cool of the Evening* by WPA muralist Richard Haines in the Berwyn Post Office, 6625 Cermak Road, depicts an ethnic picnic, with a small gathering of folks listening to an accordion player.

Route 66 (Ogden Avenue) became a two-lane U.S. highway that ran between Chicago and Los Angeles. As it ran diagonally through south Berwyn, this former Indian trail, now a thriving commercial strip, was populated with filling stations, auto dealerships, and roadside diners.

People came from all over Cook County to purchase automobiles from the dealerships in Berwyn. In 1933, L. Clark Aubrey on Harlem Avenue was selling the new V8 Ford, a durable car that had steel spoke wheels and safety glass windshields.

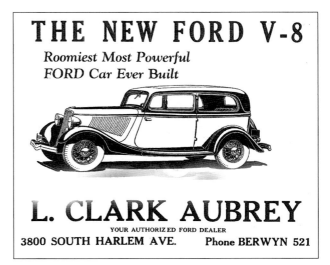

The "cut-in dance" was popular with the students of Morton Junior College during the 1930s. This fad eliminated "wall flowers" because twice as many young men as girls would be invited. The "stags" were expected to cut in on couples during every number, thus keeping everyone in virtual constant rotation.

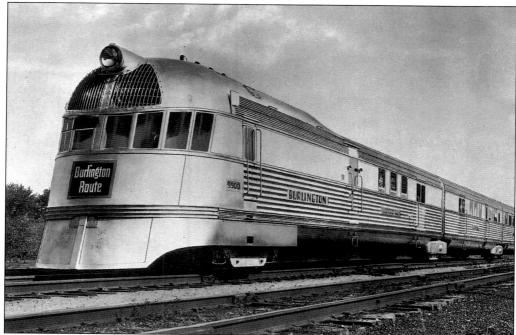

The diesel-powered, stainless steel streamliner called the Burlington Zephyr provided thrills and distraction during the Depression. When the Zephyr sped through Berwyn in 1934 en route to Chicago's lakefront for the second year of the "Century of Progress," Berwynites lined up shoulder-to-shoulder along the tracks to see it flash past. Schools closed and all the grade crossings were guarded so nothing could slow the new train's race to the World's Fair. The sleek, confident Zephyr traveled from Denver to Chicago in 13 hours, 4 minutes, and 58 seconds, averaging an unprecedented speed of 77.6 miles per hour.

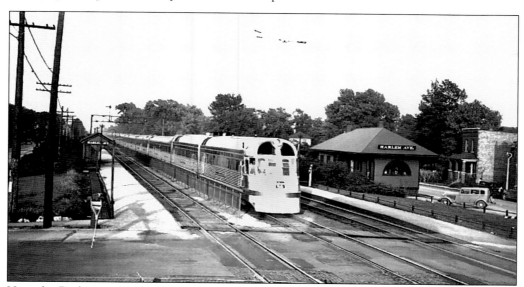

Here the Burlington Zephyr *Silver King* is doing 80 miles per hour as it speeds through Berwyn on August 29, 1937.

The Berwyn Post Office, seen here in a postcard mailed in 1939, was located at 3114 Oak Park Avenue, just south of the Oakdale Apartments. Berwyn's new post office on Cermak Road would open in 1940.

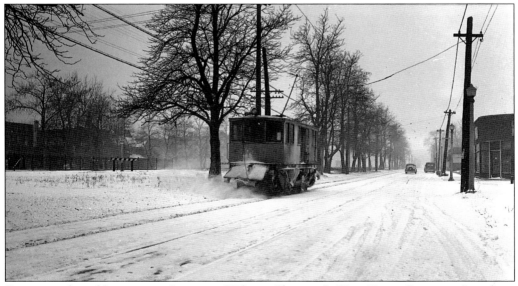

Snow was plowed by streetcar "sweepers." This is Chicago & West Towns Sweeper #9 working its way westward on Stanley Avenue at Kenilworth Avenue following a heavy snowfall in February 1938.

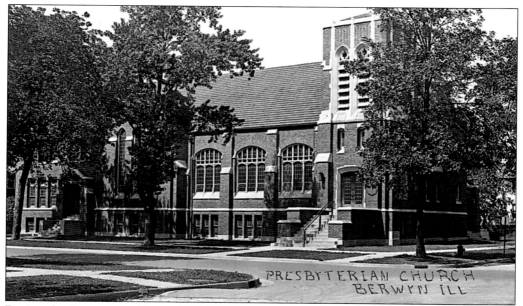

During the Depression, Berwyn's many places of worship not only served the spiritual needs of the community, they also provided an outlet for socializing. This is a postcard view of the Presbyterian Church, 32nd Street and Clinton Avenue, which was designed by Tallmadge & Watson (see page 41) in 1925. The style is modified Gothic architecture, not the usual Prairie School, the firm's specialty a decade earlier.

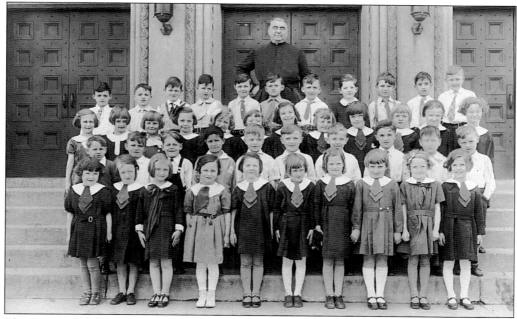

This group of children is St. Odillo's first grade class of 1935, posing with Father W.W. Roberts at 2301 Clarence Avenue. Though tuition was only 75 cents per month, many parents were hard-pressed to come up with that much money in the Depression.

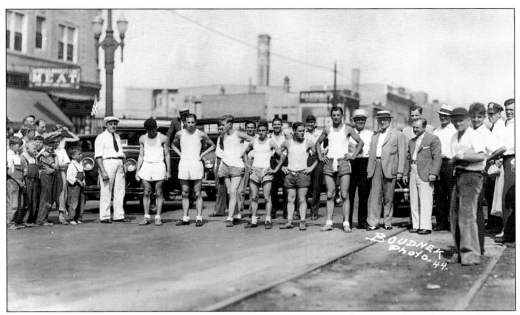

Sports played a major role in perpetuating Berwyn's ethnic vitality and often distracted young people from the hard times. The Slovak Athletic Association sponsored baseball, soccer, and bowling competitions. This race ran the length of Cermak Road in 1933.

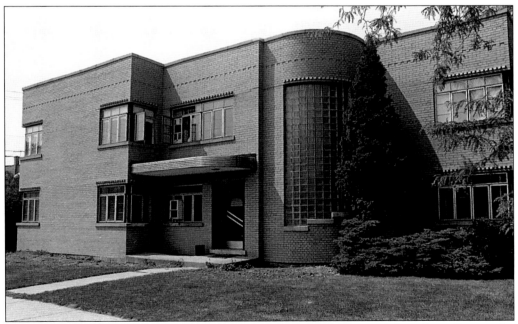

This Art Moderne apartment building at 1859 Ridgeland Avenue exhibits the influence the "Century of Progress" World's Fair had on design in the 1930s. The structure is notable for its curved glass bricks and stainless steel windows. Unfortunately, the Depression did not permit extensive construction of "deco" or "moderne" architecture in Berwyn.

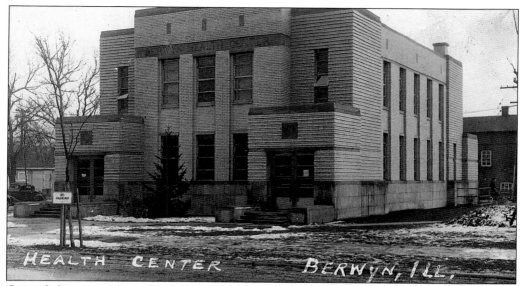

HEALTH CENTER BERWYN, ILL.

One of the most obvious and lasting legacies from Franklin D. Roosevelt's New Deal is the buildings constructed by the PWA (Public Works Administration). The 1939 Berwyn Township Health District building, located at 6600 26th Street, is typical of such architecture. Vladimir J. Novak, 2527 Ridgeland Avenue, was the architect. The flat roof and broad, horizontal emphasis, creates a streamlined, "moderne" effect. The Berwyn Post Office (1940) has similar features.

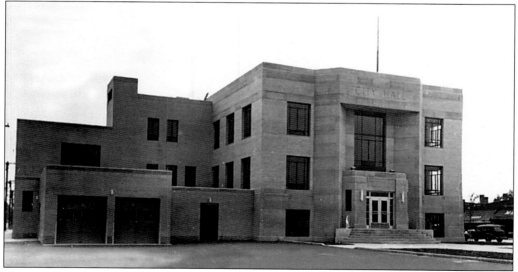

Commonly known as City Hall, the Berwyn Municipal Building (1939), 6700 26th Street, is a classic example of the Art Moderne style of architecture. The structure was erected with the aid of the WPA (Works Progress Administration), a work relief program. Before 1939, city offices were scattered around Berwyn in rented quarters. Also housed here were a fire station, the police department, and—in the basement—the Central Branch of the Berwyn Public Library. Both buildings are listed on the National Register of Historic Places.

Berwyn had many popular businesses that drew customers from other communities. Frejlach's Ice Cream, 7112 Cermak Road, sold many flavors of ice cream in seasonal shapes, such as Christmas trees or candy canes. This promotional flyer for Frejlach's was distributed in the 1930s. Many people remember going to Frejlach's on hot summer nights when customers waited in long lines to get in.

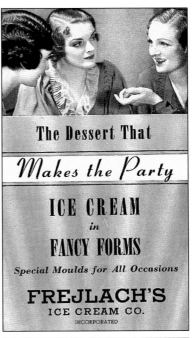

The Dessert That

Makes the Party

ICE CREAM
in
FANCY FORMS

Special Moulds for All Occasions

FREJLACH'S
ICE CREAM CO.
INCORPORATED

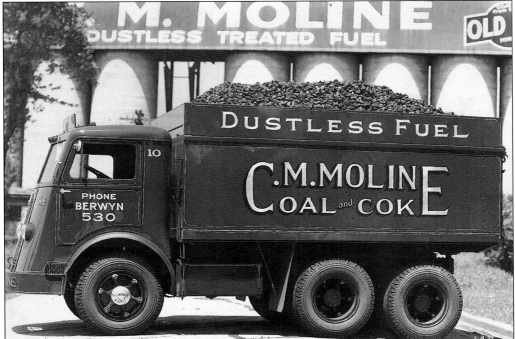

Charlie Moline, who lived at 3101 Wesley Avenue, started out as an ice man before going into the "coal business." The Moline coal yard, seen here in 1937, was at Ridgeland Avenue and the "Q" tracks. The majority of homes were heated with a coal-burning furnace. Coal was delivered by truck, then dumped down a chute into the basement where it was stored in a partitioned area called the coal bin. Note the huge coal silos.

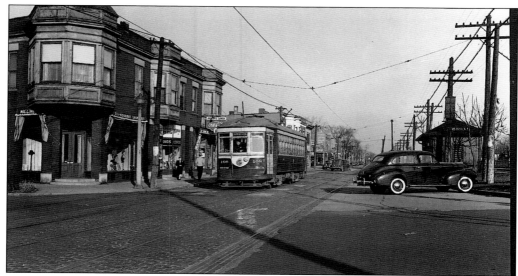

Streetcars got a lift in business due to gas rationing during World War II. But the proliferation of auto ownership after the war caused a big dip in the number of riders. The streetcars ceased operation in 1948, and the tracks were paved over.

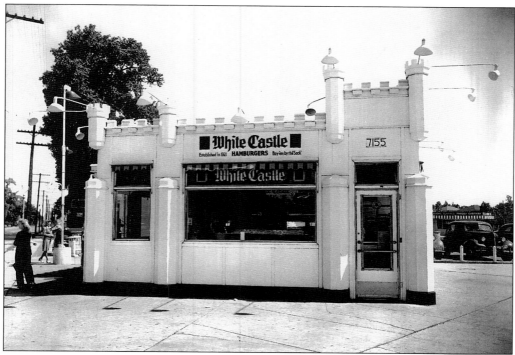

Fast food "stands" were becoming an increasing part of the culinary landscape in the 1940s. White Castle, 7155 Ogden Avenue at Harlem Avenue, was a popular roadside hamburger chain that sold "a sack of sliders for a buck." The architecture was basically a white box with overtones of a medieval castle.

People of all classes and genders wore hats when they left their homes. Women's magazines of the 1940s even advised their readers who were "feeling down" to go buy a hat. This hat-buying ritual supposedly could help "chase the blues away." Leslie's Distinctive Millinery Shop on Cermak Road at Highland Avenue is seen here, c. 1942.

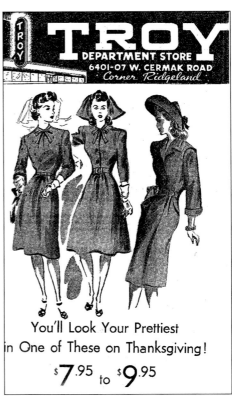

Although families relied on the Troy Department Store, 6401–6419 Cermak Road, for everything from safety pins to shoe repair, items of fashion became a mainstay. This Berwyn Beacon ad shows the popular broad-shouldered look of 1944. Though the store was a thriving business for generations, today a McDonald's restaurant is located on this corner.

Stephan's Store For Men, 6812 Windsor Avenue, sent out this postcard in 1942 to advertise tweed suits on sale for $29.50. Most young men, however, were about to don military uniforms, not business apparel.

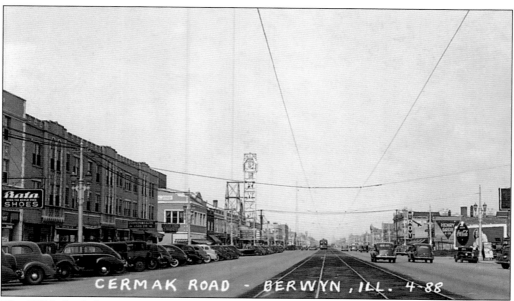

The WPA funded extensive street repair. The repaving of Cermak Road created hundreds of jobs. This 1939 postcard shows the thriving business district, a zone so crowded with Czech specialty stores, restaurants, and savings and loan businesses that it was often called the "Bohemian Wall Street." Note the trolley tracks running down the median strip.

The Parthenon movie house (page 66), 6400 Cermak Road, was renamed the Berwyn Theater when it was re-wired for "talking pictures" in 1930. The new marquee, seen here in a postcard view, was dubbed "an electric light extravaganza" in the local press. After standing empty during the 1980s, it was razed in 1990 and replaced by the LaSalle Bank. There are theatrical artifacts and several terra cotta architectural fragments from the former movie palace displayed in the bank lobby.

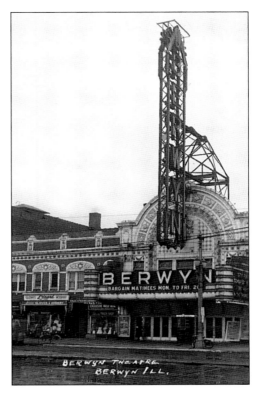

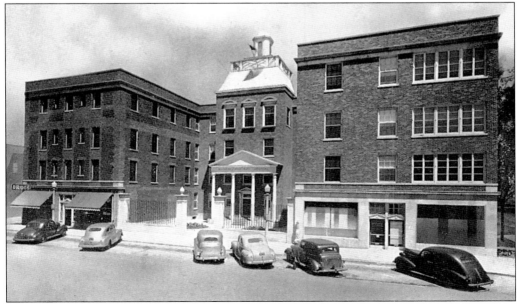

Following the death of Dr. Arthur MacNeal in 1932, his Berwyn Medical Unit was renamed MacNeal Hospital. By the time this postcard was mailed in the early 1940s, the institution had become the largest employer in Berwyn. (Compare this shot to the one on page 52. The hospital had expanded and another floor had been added.)

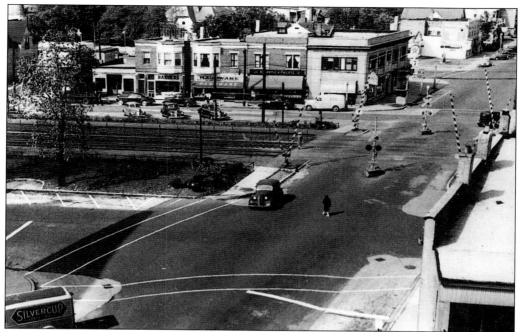

This non-rush hour, bird's-eye view shows the railroad tracks at Stanley Avenue at Oak Park Avenue, c. 1940. Then as now, the vicinity was a hub of daily commuter activity.

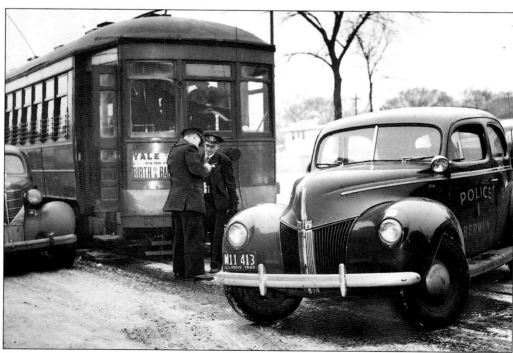

Even streetcars were not exempt from speeding tickets in Berwyn, as can be seen in this 1940 news photo.

During World War II, a starred flag in the window or on the front door indicated a son was serving "overseas."

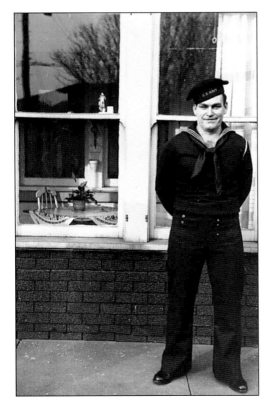

Richard Clish served with the Sea Beas in the South Pacific during World War II. This was a naval construction unit that built airstrips on islands "won back" from the Japanese, such as Guam and Okinawa.

Two of Berwyn's Victory Garden wardens pose in front of their "war office storefront" on 16th Street. To cope with wartime shortages and rationing, civilians cultivated vegetables in empty lots, former flower gardens, and even in the public parks and on school grounds. Berwyn schools instructed pupils on the planting and tending of their crops.

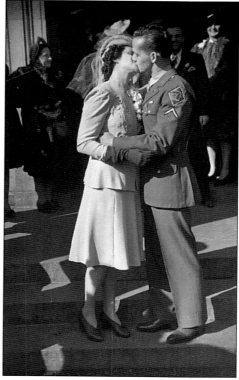

Bride and groom, Gladys and George Lhotka, kiss in front of St. Mary of Celle Church in 1943. George was leaving for Europe with the Army Infantry Division. Never before or since World War II have Americans fought with such singleness of purpose, such unanimity. Many Berwyn neighborhood groups held block parties when a soldier came home from the war.

Five

CREATING COMMUNITY

Although construction of new housing had dropped by nearly 100 percent during the Depression and World War II, the community experienced another building boom in the postwar period. Returning veterans were eager to begin peaceful lives with wives and children. The economy was strong and new housing rapidly filled in the remaining "prairies" with homes to accommodate these new families. By 1947, Berwyn ranked 11th in size among cities in the state of Illinois. Yet the community steadfastly remained strictly a residential suburb with no manufacturing industries within its city limits.

Promotional literature boasted: "More than 80 percent of Berwyn's homes and business institutions are of brick or stone construction. Most years Berwyn has the lowest fire losses of any city in the United States."

During the 1950s and 1960s, Italians, Greeks, Lithuanians, Ukrainians, Poles, and Yugoslavians moved into Berwyn, joining the Czechs to enrich the city's cultural tapestry.

The declining industrial base in adjacent Cicero, especially the closing of the massive Hawthorne Works plant in 1983, eliminated many jobs. The "graying" of Berwyn's population further resulted in smaller families and declining census figures. Many fourth and fifth generation Czechs relocated into outlying western suburbs. At the same time, a number of older businesses closed and many aging buildings began to fall into disrepair.

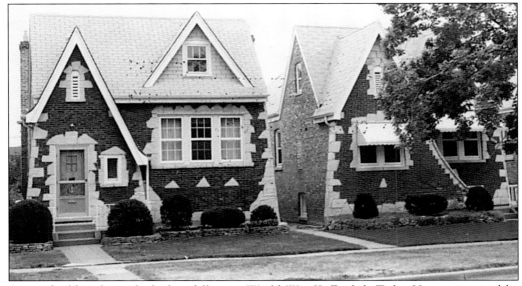

A new building boom kicked in following World War II. English Tudor Homes, inspired by steep roofs and tall chimneys of late medieval cottages, were especially popular in the late 1940s among returning veterans anxious to start families.

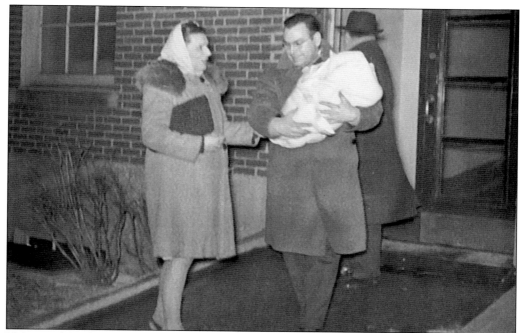

Helen and Dick Clish (page 103), are leaving MacNeal Hospital on January 14, 1948, with their baby, Richard Clish, Jr. The Baby Boom was now in full-swing.

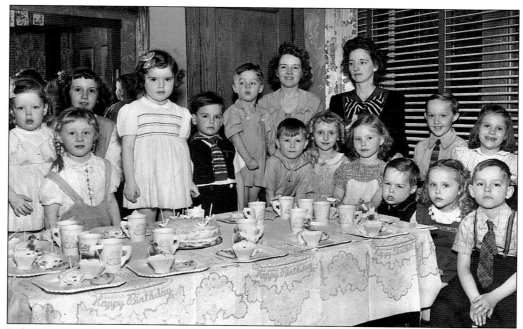

Judy McGuire (standing on the chair) is celebrating her fifth birthday with friends and cousins in February 1947 in her home, 2647 Clinton Avenue. Birthday party games at the time included kneeling on a chair and dropping clothespins into a milk bottle or pin-the- tail-on-the-donkey. Birthday cake was served with Neapolitan ice cream.

In the early 1950's, during the Korean War and the growing insecurity of the Cold War and the McCarthy Era, Berwyn focused on increasing police protection and a rigorous civil defense program.

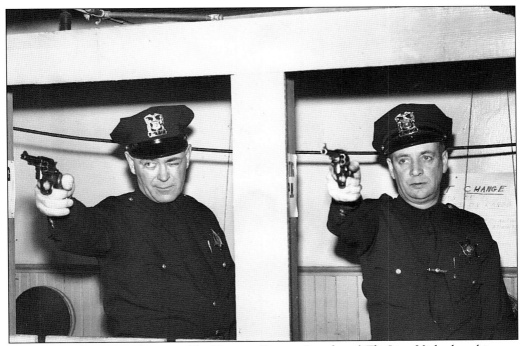

Popular cop shows on television, like *Dragnet*, *Racquet Squad*, and *The Line-Up* had nothing on Berwyn's finest. These officers are honing their sharp-shooting skills at the target range.

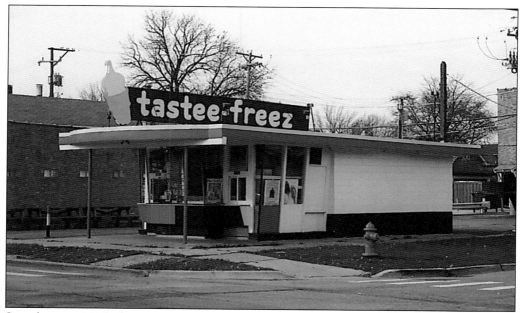

Seen here in 2005, the Tastee-Freez, 6621 26th Street, has employed generations of Berwyn teens and provided families with delicious diversions on hot summer nights since the 1950s. It won the 2003 Berwyn Historical Society Preservation Award.

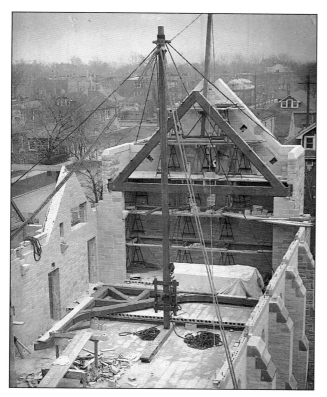

While many new homes were being constructed in Berwyn during the postwar building boom, public buildings and houses of worship were being rebuilt and expanded, too. Here Berwyn United Lutheran Church, 24th Street and Harvey Avenue, is under construction in 1950.

As families in Berwyn purchased televisions in the early 1950s, movie theater attendance drastically dropped. TV would soon dominate the communications industry. Arthur C. Nielsen, a Berwyn native son who became a household word, created the Nielsen television rating system that continues to provide an estimate of the audience for nearly every show that is broadcast. Ronnie Eadie, 1621 Grove Avenue, poses proudly with his family's new TV set.

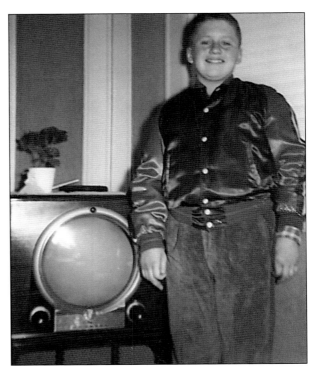

Berwyn officials in the 1950s emphasized the tranquility of family living in such a "secure suburban setting." As the Baby Boom continued, the population soared. This photo shows the "Q" tracks at Oak Park Avenue.

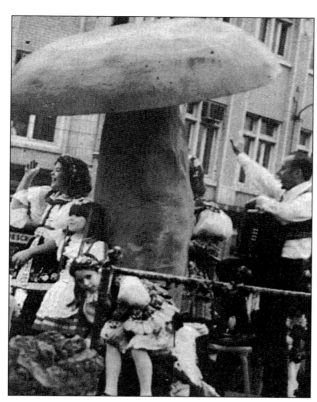

A *houby* is a mushroom. This wild fungus has long held a hallowed place in the Czech cuisine. Each year the week-long Houby Festival is held in October.

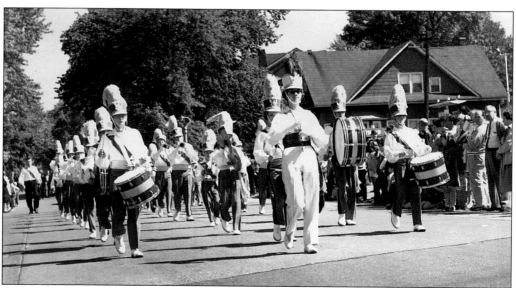

The fun-loving celebration of Bohemian life, the Houby Festival, always features a parade. These musicians are the Berwyn Blue Knights Drum & Bugle Corps. To promote the annual event, one Berwyn bank would make a playful jab at the fiscal habits of the community by issuing a "Czech Book" consisting of 10 crisp play-money dollar bills in a small folder decorated with mushrooms.

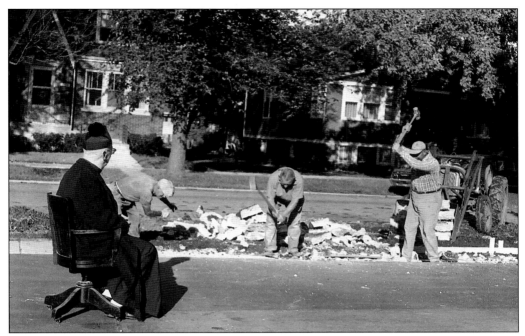

Father Patrick Buckley supervises the construction of a new parking lot at St. Odilo's parish, 2301 Clarence Avenue, in 1963.

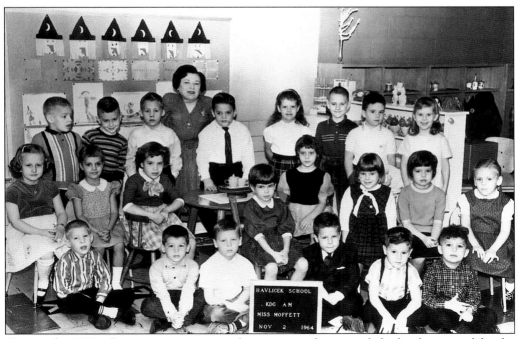

During the 1960s, Berwyn taxes rose steeply to support the expanded schools required for the Baby Boom generation. The Havlicek School, 1431 Elmwood Avenue, was named for Karel Havlicek (1821–1856), a young Czech journalist and patriot.

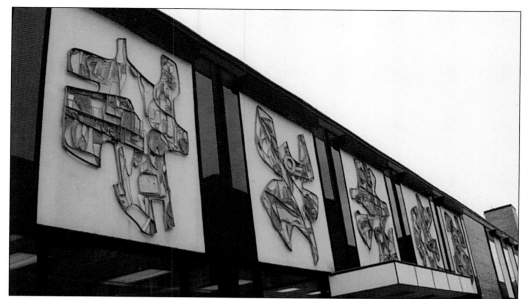

The new Commercial National Bank (now Citizens National Bank) opened in 1965 at 3322 Oak Park Avenue. Young St. Louis sculptor Saunders Schultz created five panels, 10 by 12 feet, to adorn the plain olive brick exterior of the bank. Each plexiglass and welded aluminum image celebrates the elements of a strong community: education, government, industry, transportation, and religious faith.

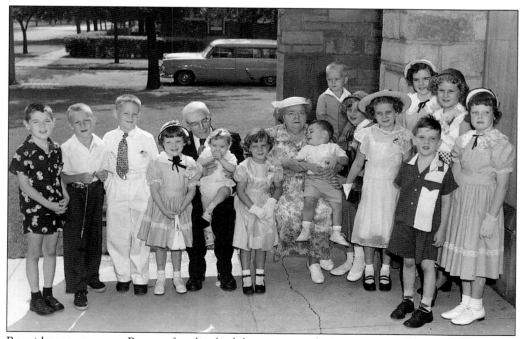

By mid-century, many Berwyn families had deep roots in their community. Martin and Blanche McGuire celebrated their 50th wedding anniversary at St. Leonard's Church, 3300 Clarence Avenue, with 14 of their 19 grandchildren in July 1953.

Parades along Cermak Road were always an integral part of the Morton High School Homecoming weekend. Students in the 1950s and 1960s enjoyed creating oversized floats for the procession.

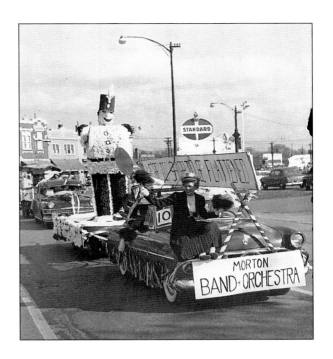

On September 3, 1958, Morton West High School opened to 2,359 students. This photo was taken seven years later, the first day of school in 1965. Morton West fronts along the 2400 block of Home Avenue. Constructed on former farmland, Morton West sported a state-of-the-art, two-story campus style structure that had seven wings designed to evenly distribute student traffic throughout the building. Berwyn finally had a high school it could call its own.

Realtors William and Lillian Baar are enjoying an evening out with friends, Mr. and Mrs. John Ondrus, at Mangam's Chateau, a nightclub at 7850 Ogden Road, in the late 1950s. Lillian opened her own real estate office, Baar Realty Company, 6335 Cermak Road, in 1943 while husband Bill was overseas with the 9th Air Force Intelligence Division. Mrs. Baar was president of the Cermak Road Business Association, the first time a woman held that office. The Baars, who lived at 1804 Cuyler Avenue, were the parents of Judy Baar Topinka, the current Illinois State Treasurer.

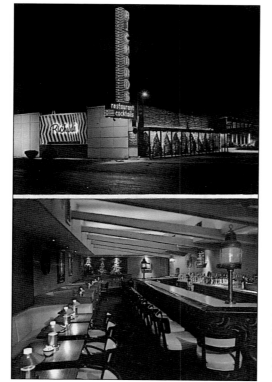

Berwyn had many popular supper clubs during the 1950s and 1960s. This postcard is from Richard's Restaurant, 3011 Harlem Avenue, known for offering "A Whole Evening's Entertainment under the Same Roof." Richard's was "recommended by Duncan Hines," a very high rating at the time.

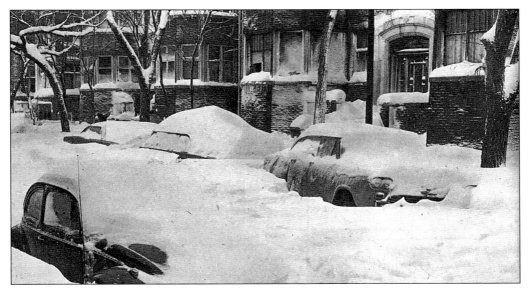

On January 26 and 27, 1967, 23 inches of snow fell with drifts up to six feet in many areas of Berwyn. It was the most severe snowstorm of the century. In 1979, the city was again brought to a standstill with another major January blizzard.

In 1968, Denise Citro, a 10th grader at Morton West High, poses in front of her family's Christmas tree, 1226 Ridgeland Avenue. During the early 1960s, a number of Italian families uprooted from the Taylor Street "Little Italy" district because the construction of the University of Illinois (formerly "Circle Campus") began to move into north Berwyn. They were followed later in the decade by a second wave of both Italians and Irish who felt displaced by an increasing influx of African Americans into the West Side.

In October 1964, four Berwyn teens each won five bucks a piece in a battle-of-the-bands. Their garage group, "The Ides of March," excelled at British Invasion-style pop rock. Jim Peterik was their lead singer, lead guitarist, and front man. The group added more guys and rose to national fame, still playing to capacity crowds over four decades later. All the original members reunited in 1990 to play at the Berwyn Summerfaire festival that drew a crowd of 25,000.

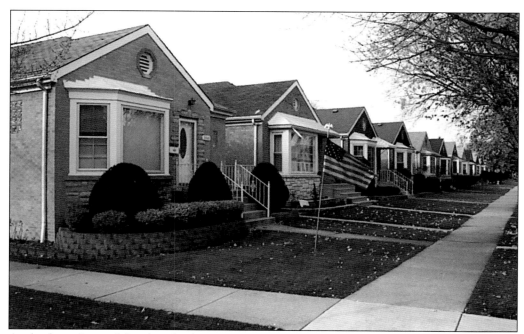

At the foot of one of the glacial ridges in west Berwyn are these late 1940s homes at 29th Street and Maple Avenue. People had tired of the traditional bungalow. But inflation had kicked in after the war so the lots are small and so are the houses.

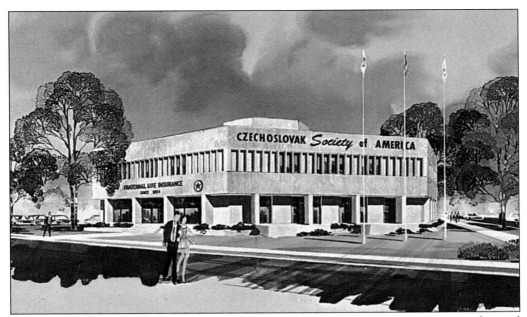

The Czechoslovak Society of America Fraternal Life Building, an insurance and social organization, 2701 Harlem Avenue, is seen here in an early 1960s artist's rendering. When CSA moved to Oak Brook in 1995, the structure was renovated and adapted to become the new home of the Berwyn Public Library.

One of the earliest outdoor malls in the region, The Cermak Plaza Shopping Center, was built in 1956 and offered 25 stores, including J.C. Penney's, Sears, two "dime stores" (Woolworth's and Murphy's), and two supermarkets (Hillman's and Jewel). The Walgreen's featured a full restaurant and grill.

In 1980, David Bermant, owner of the Cermak Plaza Shopping Plaza and a national patron of the arts, commissioned Nancy Rubins to construct a work entitled *Big Bil-Bored* for $25,000. This three-story, sixty-ton, pork chop-shaped sculpture made of hundreds of castoff appliances immediately outraged Berwynites, who demanded the sculpture be torn down. Ultimately, however, it was the rusting of its metal components that made the work unstable. It was removed from the mall in 1993.

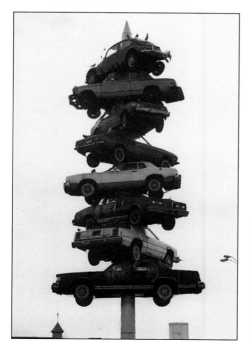

In 1989, Dustin Schuler was paid $75,000 by Bermant for *The Spindle*, an attention-grabbing stack of eight full-sized automobiles skewered on a huge vertical spike. Once again the citizens wanted this piece taken down, complaining that the towering work attracted pigeons. But the protest quieted after the sculpture appeared in the movie *Wayne's World* (1992), starring Mike Myers and Dana Carvey. It is said that Berwyn police dispatchers like to send rookies out to the Plaza to investigate the "eight-car pile-up."

Six

FACING THE FUTURE

Berwyn has at times been painted as a tough-edged town resistant to change. But change is no stranger to Berwyn. Much of the strength of the community has been its ability to adapt and thrive while continually redefining itself.

Beginning in the 1990s, Berwyn experienced a significant influx of young families as well as single professionals. They were attracted to the community by the convenient location, the well-built, affordable housing, and the safe, clean neighborhoods. The Hispanics who began to make their homes in Berwyn mirrored the Eastern Europeans who arrived earlier in the century. Moving out of their crowded city neighborhoods, they arrived seeking a "better environment" for their families and the chance to improve the quality of their lives by becoming Berwyn homeowners.

Although a few old landmarks and commercial sites were demolished or were adapted in ways that rendered them no longer recognizable, Berwynites began to restore and recycle many other aging buildings, preserving and protecting the community's architectural heritage. In the twenty-first century, Berwyn keeps working hard to improve its appearance.

Despite the loss of industry in adjacent communities, Berwyn took steps to keep its economy strong, such as by initiating tax increment financing districts. Thus the city has maintained a strong local commercial base. Latino-owned businesses, ranging from shoe stores to travel agencies, from bridal shops to bakeries, illustrate the growing economic power of Berwyn's Mexican population.

Real estate values continue to skyrocket. The bungalow style experienced a revival in the 1990s. These well-built residences, cared for by generations of hard-working Berwynites, were once again appreciated for their solid construction and craftsmanship. Homeowners realized their brick homes with hardwood-trim interiors could never be duplicated for the same price elsewhere in the suburbs.

In the twenty-first century Berwyn continues to change and evolve while preserving its traditional values. There are now 55,000 people living in Berwyn, up from the 1990 U.S. census count of 45,000.

Residents are justly proud of "Beautiful Berwyn." As many young Berwynites like to say, "It's happening here!"

During the 1990s, members of the Hispanic community began joining the ethnic mix that makes up Berwyn. These happy lads peer down the hall at St. Odilo School, 23rd Street and East Avenue.

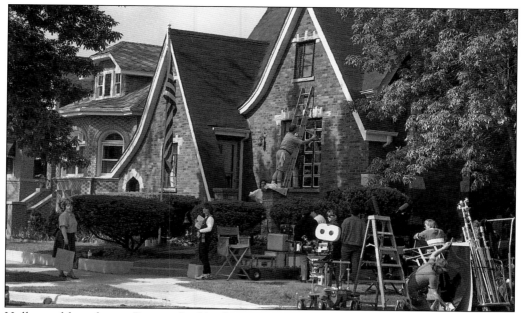

Hollywood has chosen Berwyn for film locations on numerous occasions. Here actress Kathy Bates waits for an okay that the crew is ready to shoot her next scene in front of an English Tudor in *Prelude to a Kiss* (1992).

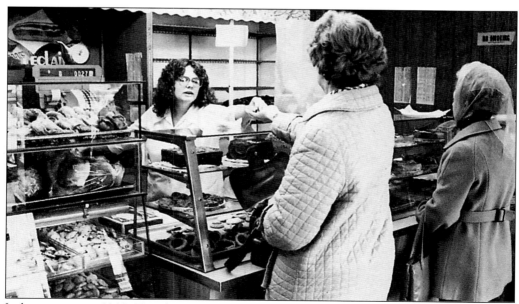

In business since 1919, Vesecky's Bakery, 6234 Cermak Road, continues to sell Czech breads, biscuits, cookies, coffee cakes, kolaches, babovka, houska, and prune pie.

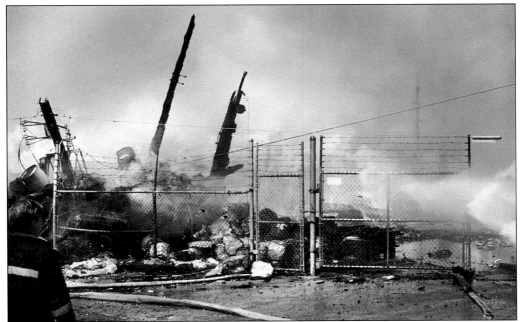

The Easter Sunday Fire at the Berwyn Lumber Company in 1977 was the biggest fire in the history of the community.

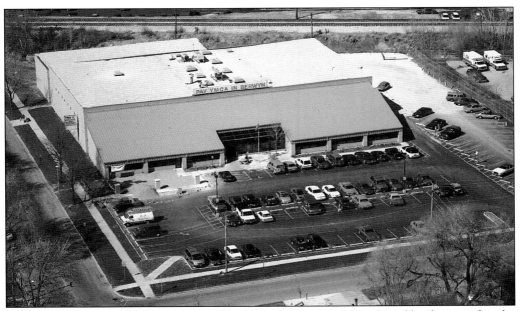

The large new YMCA, a 40,000-square foot facility on two acres purchased by the city after the disastrous 1977 lumberyard fire at 39th Street and Oak Park Avenue, opened in 1987. Located at 2947 Oak Park Avenue, the PAV "Y" has an Olympic-sized pool, racquet and handball courts, a gym, and exercise facilities, including a cardiac rehabilitation center operated with MacNeal Memorial Hospital.

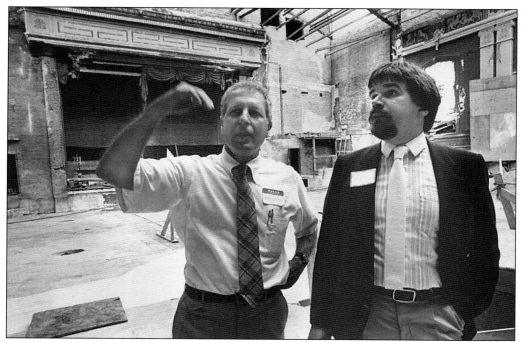

Although many buildings seen as useless or outdated were razed during the 1980s, others were recycled and given exciting new purpose. Architect Errol J. Kirsch (left) designed Atrium Court, a 52-unit condominium complex in the former Ritz movie theater building, 6344 Roosevelt Road (page 68).

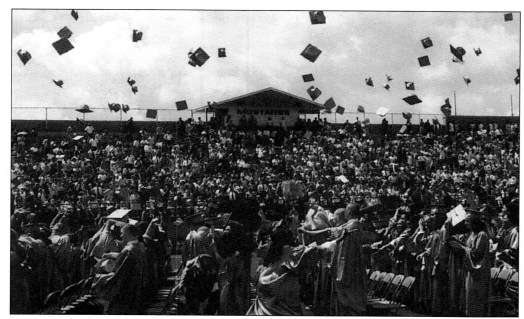

Ready to begin their new lives, the senior class of 1996 at Morton West High School tosses their caps into the air at the end of their outdoor graduation ceremony.

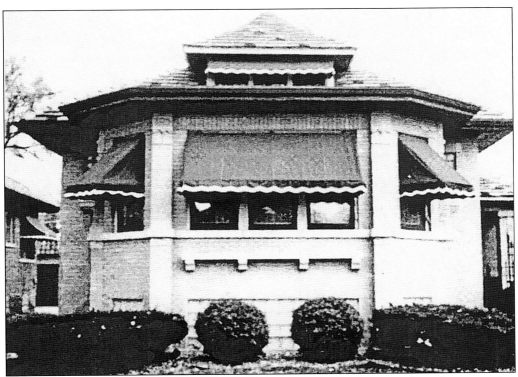

This brick home at 3025 Maple Avenue, with its wide overhanging eaves and windows wrapping around the octagonal front, was the winner of the 1995 Berwyn Historical Society Bungalow Preservation Award. During the 1990s, the bungalows enjoyed a major revival of popularity and were celebrated for their historical significance, quality workmanship, and lasting beauty.

On Cermak Road, a young Girl Scout participates in the annual Houby Parade dressed as the Statue of Liberty in 2001.

Children at Heritage Middle School, 6850 31st Street, sing traditional Mexican songs during the annual Cinco de Mayo/Mother's Day Festival in 2002. Berwyn elementary school students sing and dance each year for their parents in the school's gym.

These are four of the over 100 members of BUNGALO, incorporated on March 25, 1995, a group that frequently participates in community service projects. The acronym stands for the Berwyn United Neighborhood Gay and Lesbian Organization.

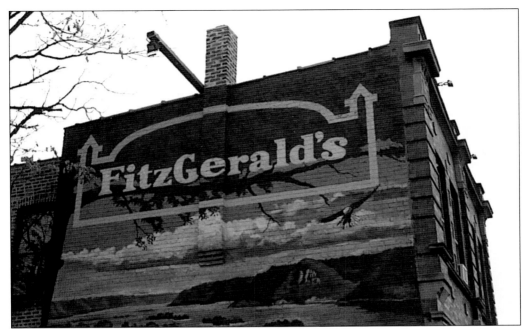

Fitzgerald's, 6611–6615 Roosevelt Road, a popular nightclub featuring rock, blues, Zydeco, and country music, is situated in several linked buildings that were roadhouses during the Prohibition era. Movie scenes with Paul Newman and Tom Cruise were filmed here for Martin Scorsese's *The Color of Money*(1986) and for *A League of Their Own* (1992) with Madonna and Tom Hanks. Fitzgerald's won the 2004 Berwyn Historical Society Preservation Award.

The Berwyn Park District has been creating beautiful environments for the community for over 85 years. Here Carlos Velasquez is reading to his daughter Elizabeth and son Enrique in Sunshine Park near 29th Street and Oak Park Avenue in 1994.

Proksa Park, 31st Street and Home Avenue, was named after Joseph Proksa, Berwyn's long-time park district superintendent. After assuming office in 1929 he created these 17 1/2 acres into one of the prettiest small parks in the Midwest. Proksa himself built the berms, then planted the trees and flowers.

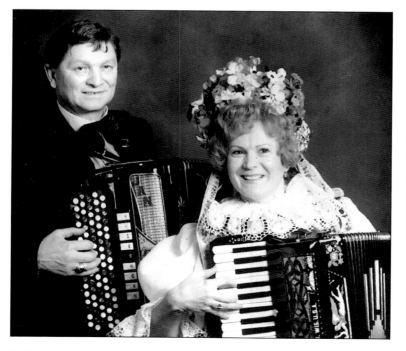

Vlasta, the "International Polka Queen," is seen here with her husband, Jan Krsek. Vlasta was featured on television shows from Johnny Carson's to Larry King's and appeared in the teen comedy *Ferris Bueller's Day Off* (1986). That year, she also played her "Happy Birthday Polka" at President Ronald Reagan's 75th birthday party.

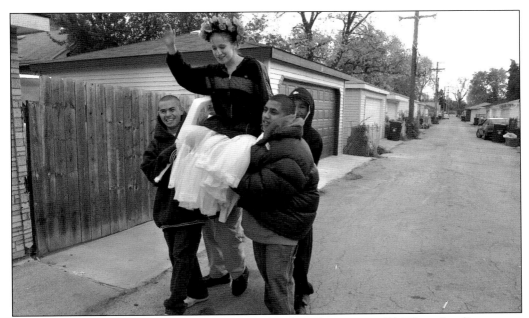

The most significant birthday for Mexican girls takes place at age 15. Their families put on a coming-of-age party called a *quinceanera*. The preparations for both the parents and the debutante can rival many weddings. Here Jennifer Torres is carried by her *chambelanes* (escorts) as they rehearse in the alley of the 2600 block of Euclid Avenue. There were 250 guests at the celebration and Torres danced to six traditional waltzes.

Lori Thielen, President of the Berwyn Historical Society, is dusting off one of the artifacts from the archives, a toy truck from the 1920s. The organization actively strives to preserve the past while focusing on the future.

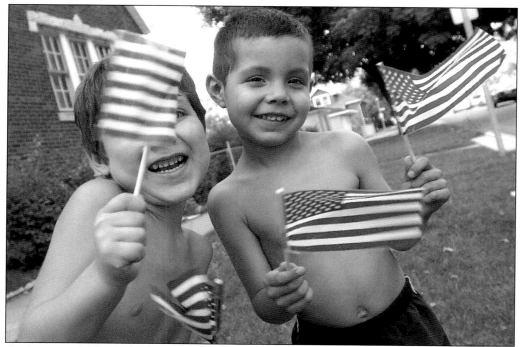

At the annual Third of July parade, Daniel Velasquez and his cousin Ramon Salazar cheer on the participants as they wave flags at Oak Park Avenue near 27th Street.

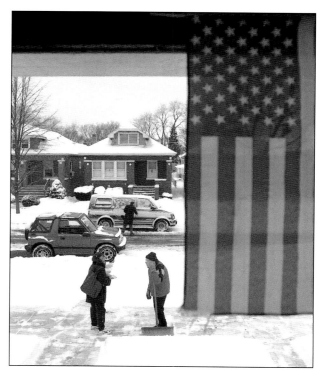

Berwyn continues to attract hard-working people who take pride in their homes and celebrate the fulfillment of the American Dream. In 2001, Rocio Perez talks with her neighbor, Joe Adamczyk, in the 2700 block of Euclid Avenue.